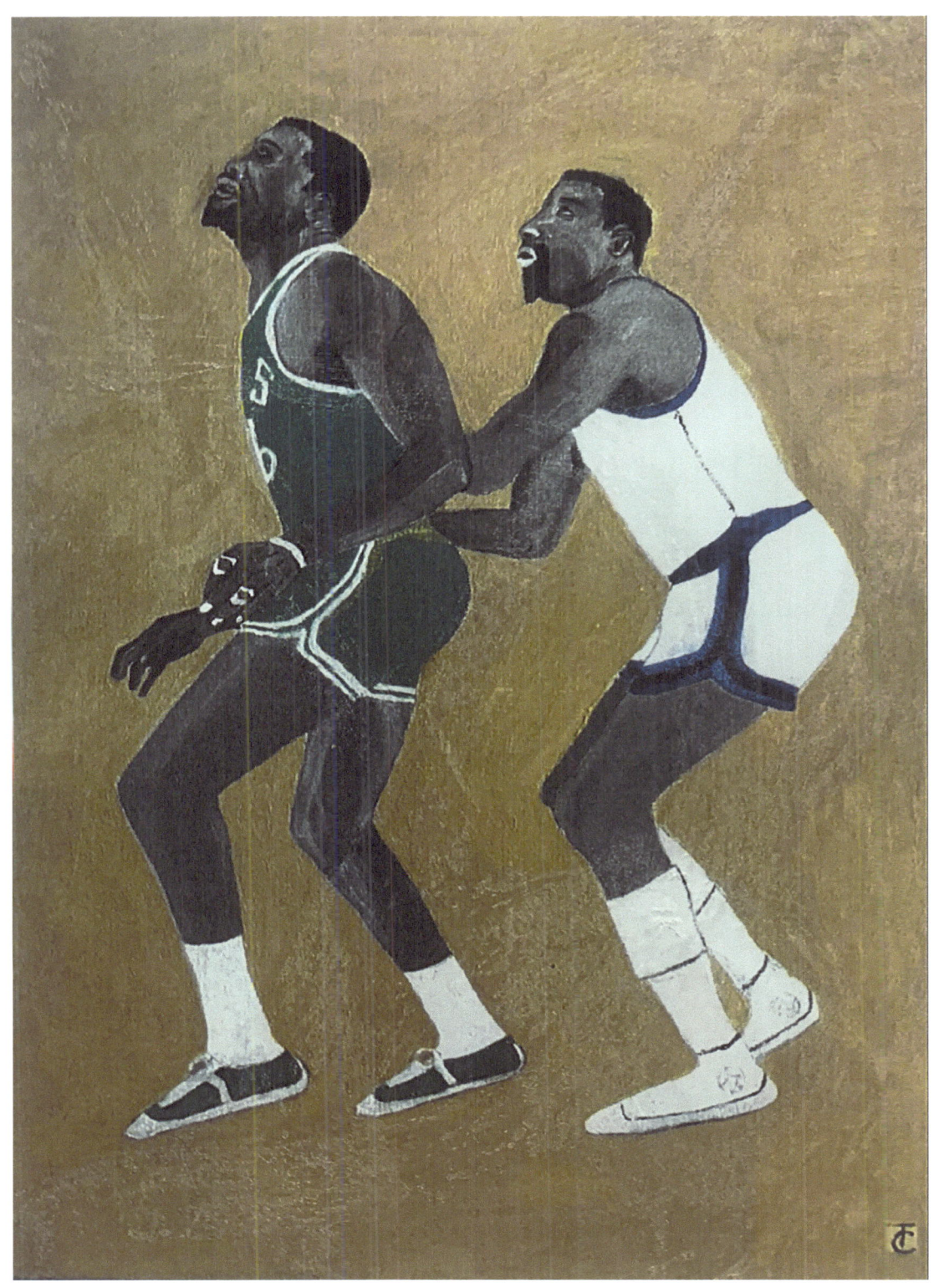

Basketball Portraits

Thomas Crawford

Copyright © 2024 by Thomas Crawford

All rights reserved.

No part of this book may be reproduced in any form or by any electronic or mechanical means, including information storage and retrieval systems, without permission in writing from the publisher, except by reviewers, who may quote brief passages in a review.

This publication contains the opinions and ideas of its author. It is intended to provide helpful and informative material on the subjects addressed in the publication. The author and publisher specifically disclaim all responsibility for any liability, loss or risk, personal or otherwise, which is incurred as a consequence, directly or indirectly, of the use and application of any of the contents of this book.

WORKBOOK PRESS LLC
187 E Warm Springs Rd,
Suite B285 Las Vegas NV 89119 USA

Website: https://workbookpress.com/
Hotline: 1-888-818-4856
Email: admin@workbookpress.com

Ordering Information:
Quantity sales. Special discounts are available on quantity purchases by corporations, associations, and others. For details, contact the publisher at the address above.

ISBN-13: 978-1-961845-27-5 Hardback Version
 978-1-961845-28-2 Digital Version

REV. DATE: 01/12/2024

INTRODUCTION

Basketball was a team sport in the twentieth century and was played almost exclusively in the first fifty years of its existence on the North American continent by Americans. Today it is internationally popular and widely watched on all continents. The game has evolved and changed dramatically. Until 1950 there were no African-Americans or Europeans playing professionally in the National Basketball Association (NBA). Today the majority of NBA players and superstars are African-American and there are many dominant players from Europe, Africa, and South America.

Since the 1950s basketball has steadily grown as the favorite neighborhood, backyard, city street pick-up game in America and in many countries around the world. In many parts of the United States and Canada, it is the most popular high school spectator sport. Television has made the NBA internationally popular and a financial gold mine for professional players. Forty years ago, a six-foot-three-inch guard in the NBA was a rarity; today a guard measuring less than six feet three inches tall is a rarity. The speed, size and leaping ability of NBA players has increased dramatically creating a nonstop spectacle of athleticism.

Comparing the skills of players from different generations is not the purpose of this book. Nor does the fact that there are no portraits of such players as Duane Wade, Steve Nash, Kawhi Leonard, Kevin Durant or the big, young Serbian Nicola Jokic diminish their legitimate claims to pre-eminence among superstars. Rather, this book is made in appreciation of the excellent basketball players, including teammates and opponents George Selleck (Stanford), Bill Bloom (USC), Bobby Wendell and Joe Kapp (Cal), Fred Crabtree (UCLA), and Tom Meschery (St. Mary's).

Tom Crawford
August 18, 2023

List of Portraits

1. ANGELO-GIUSEPPI "HANK LUISETTI", b. 1916, San Francisco, CA, d. 2002, CA ht. 6'2'
2. REECE "GOOSE" TATUM, b. 1921, Eldorado, AR, d. 1967, AR ht. 6'6"
3. DON BARKSDALE, b. 1923, Oakland, CA, d. 1993, Oakland, CA ht. 6'6"
4. GEORGE MIKAN, b. 1924, Joliet, IL, d. 2005, Scottsdale, AR ht. 6'10"
5. BOB COUSY, b. 1928, New York, NY ht. 6'1"
6. K.C. JONES, b. 1932, Taylor, TX, d. 2020, CT ht. 6'1"
7. BILL RUSSELL, b. 1934, Monroe, LA ht. 6'10"
8. BILL RUSSELL and K.C. JONES
9. ELGIN BAYLOR, b. 1934, Washington, D.C., d. 2021, CA ht. 6'5"
10. WILT CHAMBERLAIN, b. 1936, Philadelphia, PA, d. 1999, CA ht. 7'1"
11. OSCAR ROBERTSON, b. 1938, Charlotte, TN ht. 6'5"
12. JERRY WEST, b. 1938, Chelyan, WV ht. 6'3"
13. PAUL NEUMANN, b. 1938, Newport Beach, CA ht. 6'1"
14. JOHN HAVLICEK, b. 1940, Martins Ferry, OH, d. 2019, FL ht. 6'5"
15. BILL BRADLEY, b. 1943, Crystal City, MO ht. 6'5"
16. LEW ALCINDOR (KAREEM ABDUL JABBAR, b. 1947, New York, NY ht. 7'2"
17. LARRY BIRD, b. 1956, West Baden Springs, IN and ht. 6'9"
18. EARVIN "MAGIC" JOHNSON, b. 1959, Lansing MI ht. 6'9"
19. CLYDE DREXLER, b. 1962, New Orleans, LA ht. 6'7"
20. JOHN STOCKTON, b. 1962, Spokane, WA ht. 6'1"
21. KARL MALONE, b. 1963, Ruston, LA ht. 6'9"
22. HAKEEM OLAJUWON, b. 1963, Lagos, Nigeria ht. 6'10"
23. MICHAEL JORDAN, b. 1963, Brooklyn, NY ht. 6'6"
24. JASON KIDD, b. 1973, San Francisco, CA ht. 6'4"
25. TIM DUNCAN, b. 1976, Saint Croix, U.S. Virginia Islands ht. 6'11"
26. KOBE BRYANT, b. 1978, Philadelphia, PA, d. 2020, Los Angeles, CA ht. 6'6"
27. DIRK NOWITZKI, b. 1978, Wurst, Germany ht. 6'6"
28. LEBRON JAMES, b. 1984, Akron, OH ht. 6'9"
29. STEPH CURRY, b. 1988, Akron, OH ht. 6'3"
30. JAMES HARDEN, b. 1989, Los Angeles, CA ht. 6'5"
31. LUKA DONČIĆ, b. 1999, Ljubljana, Slovania ht. 6'7"

ANGELO-GIUSEPPI "HANK LUISETTI"

b. 1916, San Francisco, CA d. 2002, CA 6ft. 2in 185 lbs.

As a Stanford senior playing in 1938 in Madison Square Garden in a game against Duquense Hank Luisetti became the first player to score 50 points. He is credited with developing the running one-handed shot, an earlier version of today's jump shot. He was such a dominant player in college basketball that, it is said, he could take over a game, like Michael Jordan, if he had to. He was an all-around player of such an ability that an Associated Press poll of sports writers in 1950 named Luisetti the second best player of the mid-century behind George Mikan.

After serving in the U.S. Navy, he contracted spinal meningitis and was unable to enter the NBA or play competitively again. Though not classmates, both Hank Luisetti and Joe DiMaggio attended Galileo High School in San Francisco.

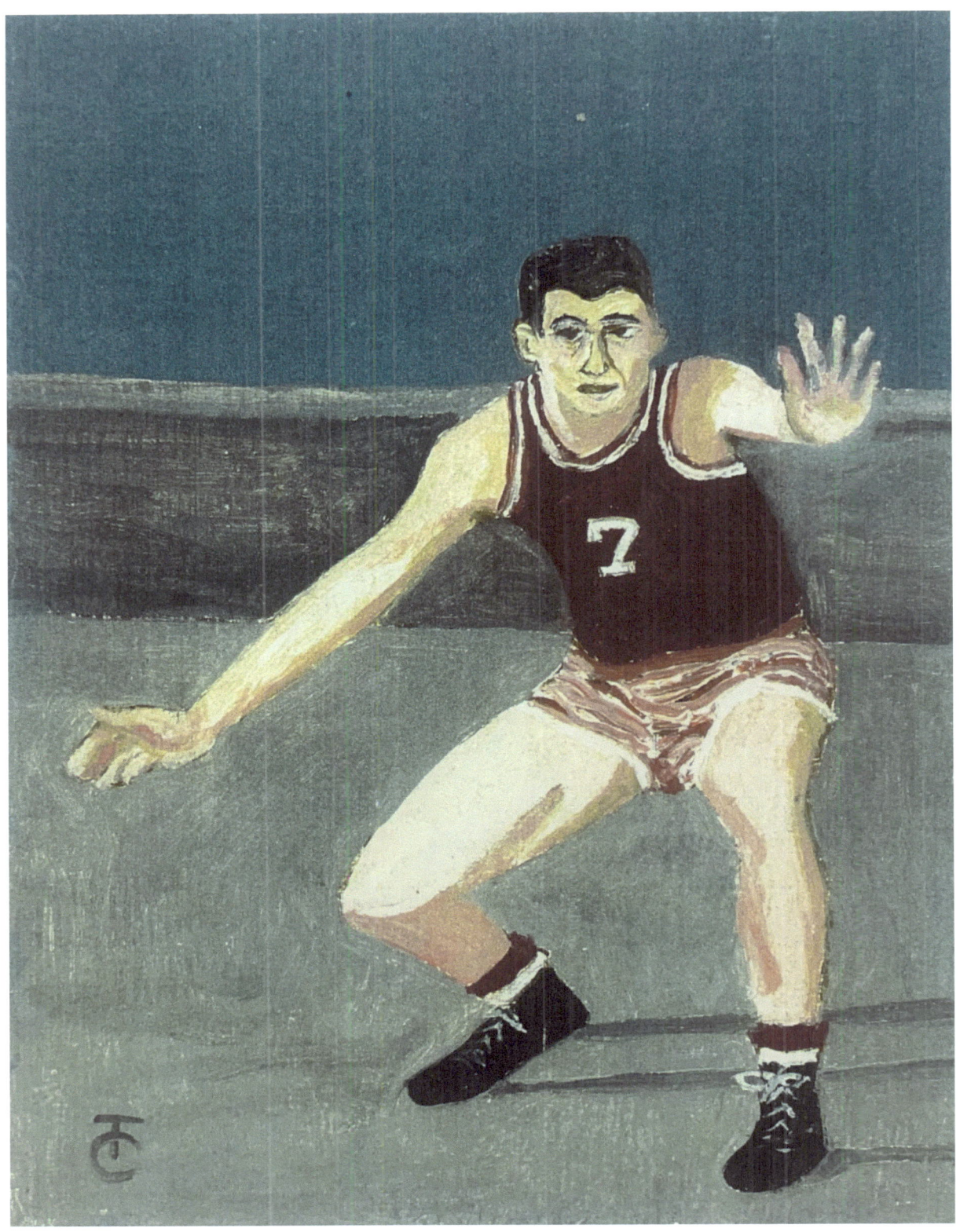

REECE "GOOSE" TATUM

b. 1921, Eldorado, AR d. 1967, AR 6 ft. 6 in.

The "Clown Prince" and greatest of the Harlem Globetrotters was an all-around superb athlete, who once said that his goal in life was "to make people laugh." Goose Tatum delighted all who saw him play and he, perhaps more than any other player, was an inspiration to aspiring young basketball players of my generation. He represents to basketball what Satchel Paige does to baseball.

Goose barnstormed with the Harlem Globetrotters from 1940 to 1955, except for 1943-44 when he was serving in the U.S. military. In a 1948 one-game basketball showdown Tatum and the Trotters upset George Mikan and Vern Mikkleson's world champion Minneapolis Lakers. From 1956 to 1966, one year from his death at age 45, he toured with various Harlem-based teams.

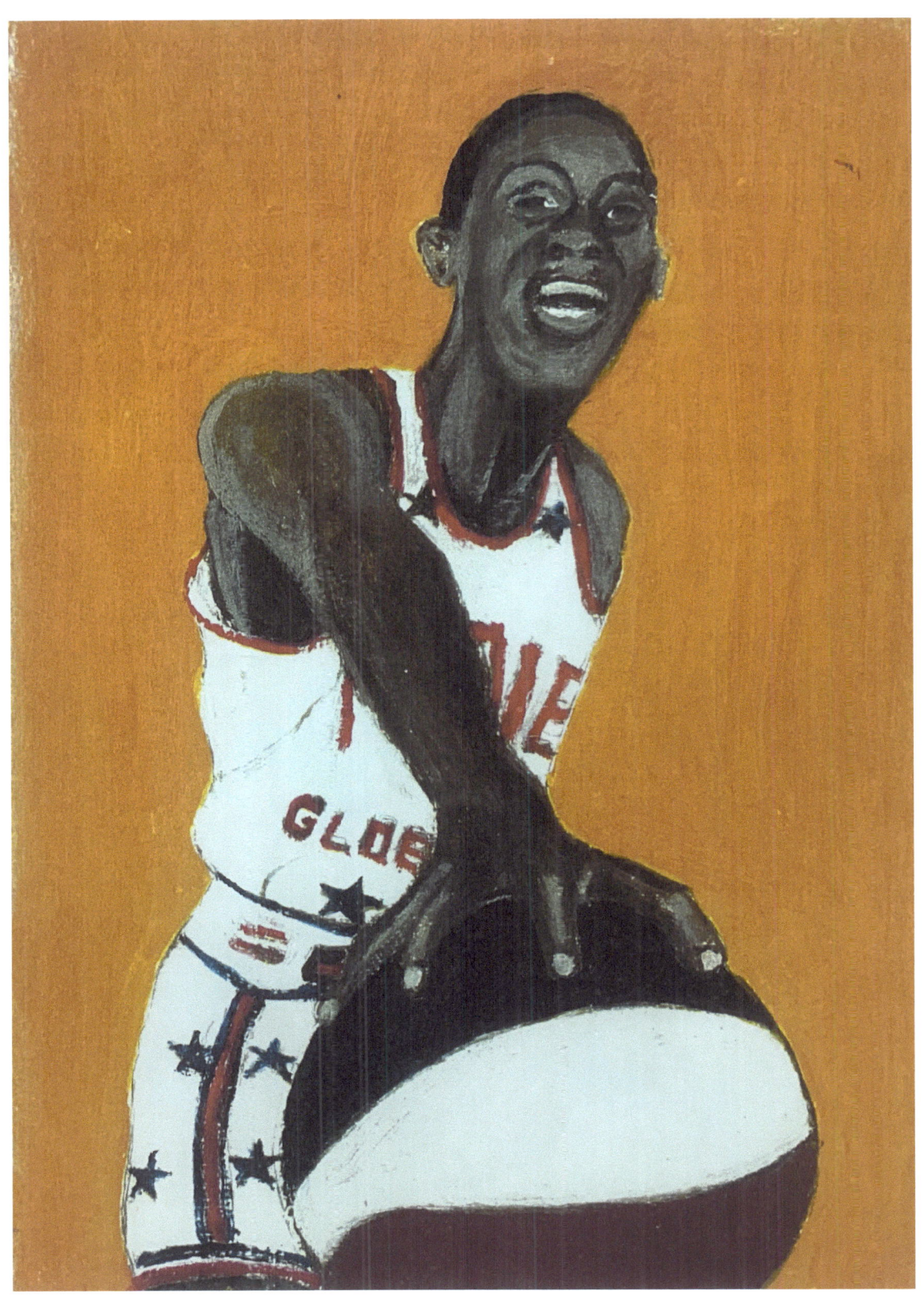

DON BARKSDALE

b. 1923, Oakland, CA d. 1993, Oakland, CA 6 ft. 6 in. 200 lbs.

When Don Barksdale attended UCLA in the late 1940s, he was the premier player on the West Coast. He was my favorite player and though I never saw him play I felt that I knew his every move based on Sam's Balter's reliable radio broadcasts.

Before entering the NBA as a Baltimore bullet in 1951, Barksdale developed his superb all-around game at Berkeley High, College of Marin and UCLA. He was the first African American to be named a consensus AllAmerican (1947 and to play on an Olympic team and win a gold medal (1948). Although he was not the first African American to play in the NBA, he was the first to play in an NBA All-Star game.

Playing for Baltimore (1951-53) and the Boston Celtics (1953-55) his NBA career stats are:

Points: 2,895 (11.0 ppg)
Rebounds: 2,088 (8.0 ppg)
Assists: 549 (2.1 avg.)

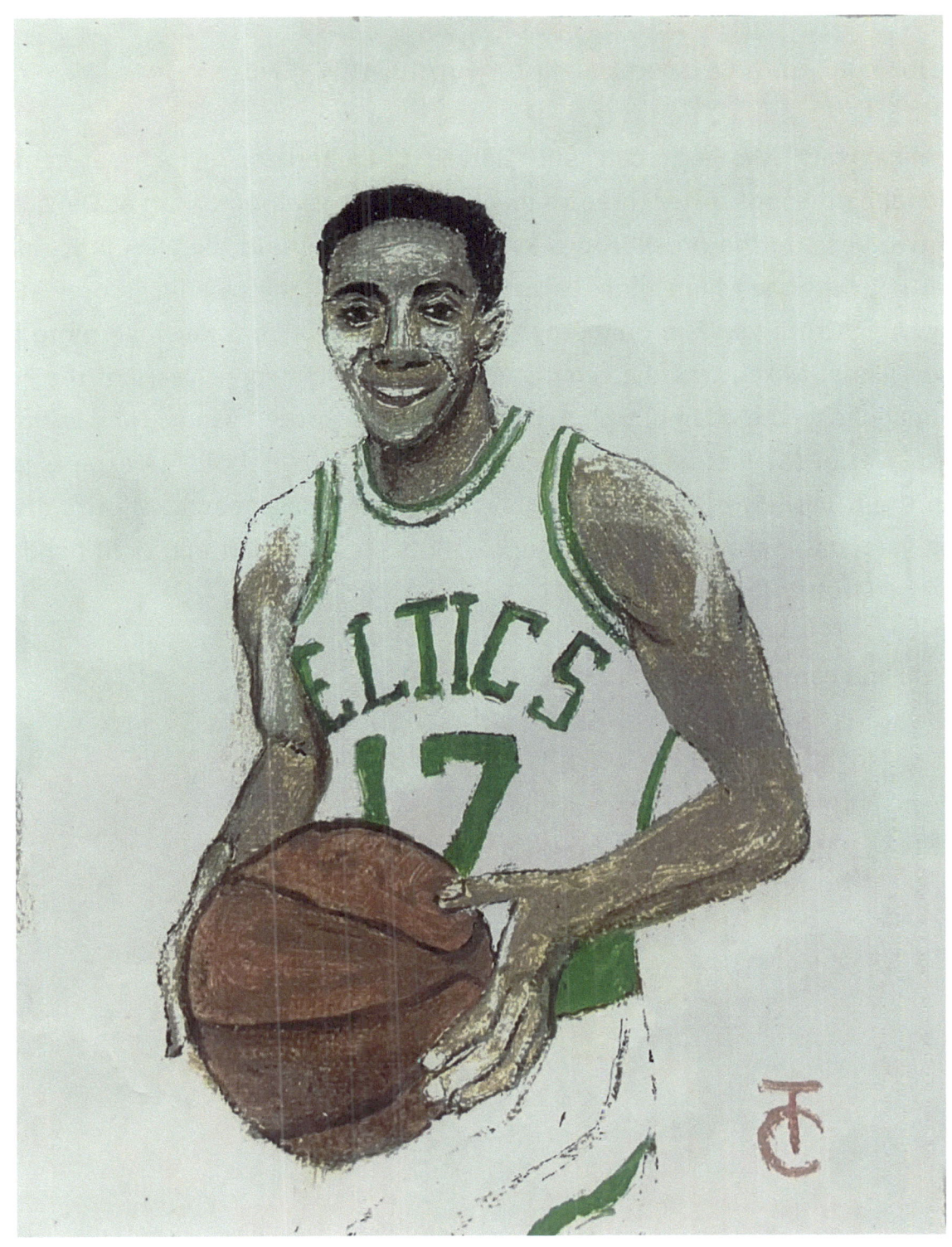

GEORGE MIKAN

b. 1924, Joliet, IL d. 2005, Scottsdale, AZ 6 ft. 10 in. 245 lbs.

George Mikan was "Mr. Basketball" until Russell, Chamberlain, Baylor, et al. came on to the national hardwoods. After three years as a consensus all-American at DePaul (1944-46) and two years in the pre-NBA pro leagues, Mikan entered the NBA in its inaugural season (1949) with the Minneapolis Lakers. He was the league's leading scorer, averaging 27.4 ppg. Alex Groza was the only other player in the league to average more than 20 points per game. Mikan was the scoring leader in the first three years of the NBA and led Minneapolis to the championship in two of those three seasons. He was voted the greatest player of the first half of the century in 1950. A panel of NBA experts included Mikan in the NBA's 25th (1970) and 35th (1980) anniversary teams. Mikan's distinctive offensive weapons were ambidextrous hook shots (i.e. both left and right-handed) and underhanded free-throws.

George Mikan's career pro stats from 1946- 56 are:

Points: 11,764 (22.6 ppg)
Rebounds: 4,167 (13.4 rpg) [five seasons in NBA only]
Assists: 1,245 (2.8 apg) [B AA and NBA only, six seasons]

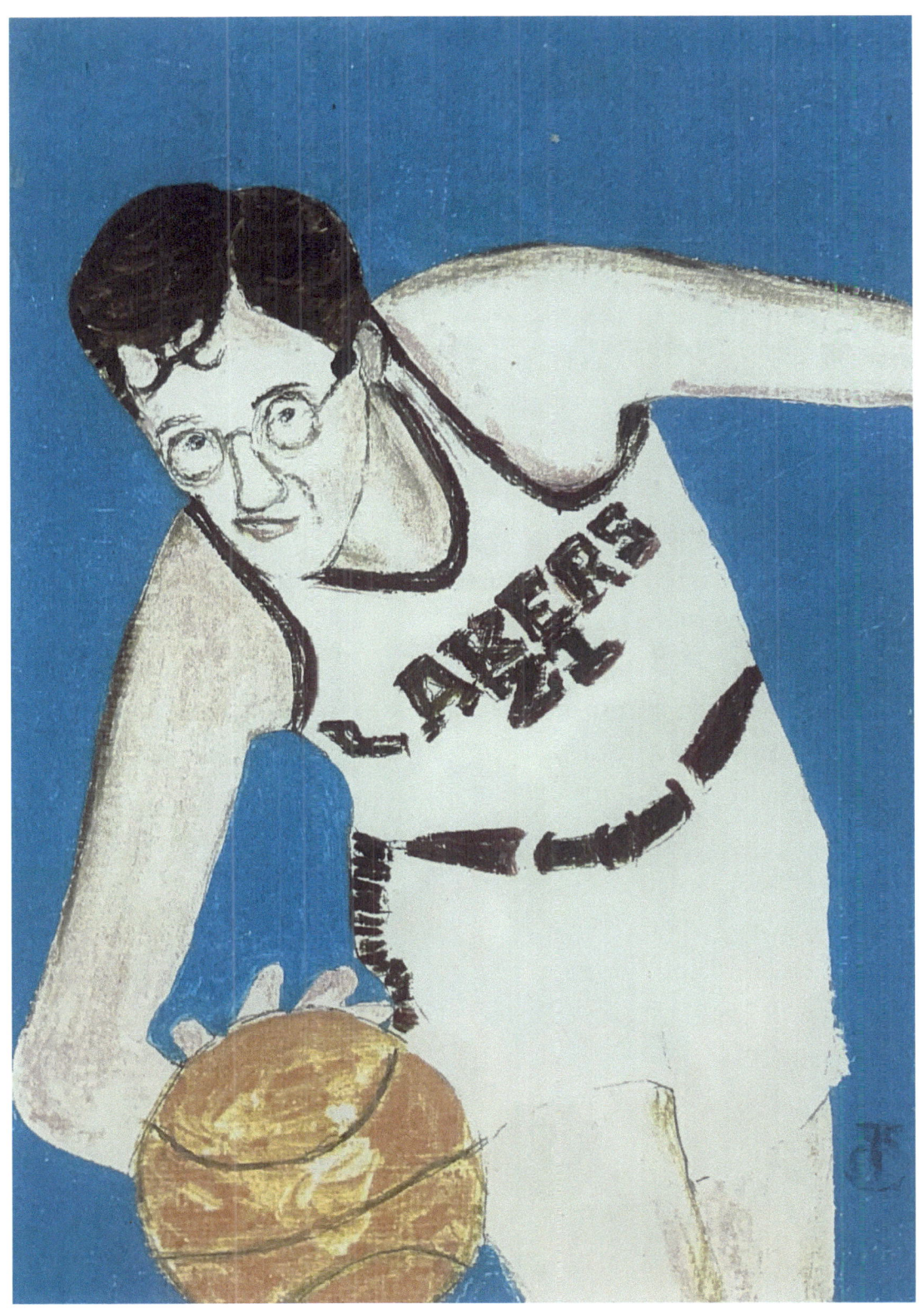

BOB COUSY

b. 1928, New York, NY 6 ft. 1 in. 175 lbs.

Called "Houdini of the Hardwood" Bob Cousy was a superlative ball handler, passer and scorer who led the Boston Celtics to six NBA championships. As a child born of French immigrants who spoke only French until the age five, I prefer to think of him as the "Cyrano of Basketball." Cousy and Marques Haynes of the Globe Trotters were in disputedly the best dribblers in basketball and the idols of every aspiring young point guard growing up in the 1950s.

Cousy's college basketball experience at Holy Cross was up and down, or down and up. He played sparingly off the bench his first year and considered transferring to another school his second year, even though Holy Cross had won the NCAA championship. In his final year Cousy was a consensus All-American.

Cousy's accomplishments in his thirteen seasons with the Celtics are impressive:
6 x NBA champion; 13 x NBA All-Star; 2 x NBA All-Star game MVP; 10 x All-NBA first team; 8 x NBA assists leader.

Bob Cousy's career NBA statistics are :

Points: 16,960 (18.4 ppg)
Rebounds: 4,786 (5.2 rpg)
Assists: 6, 955 (7.5apg)

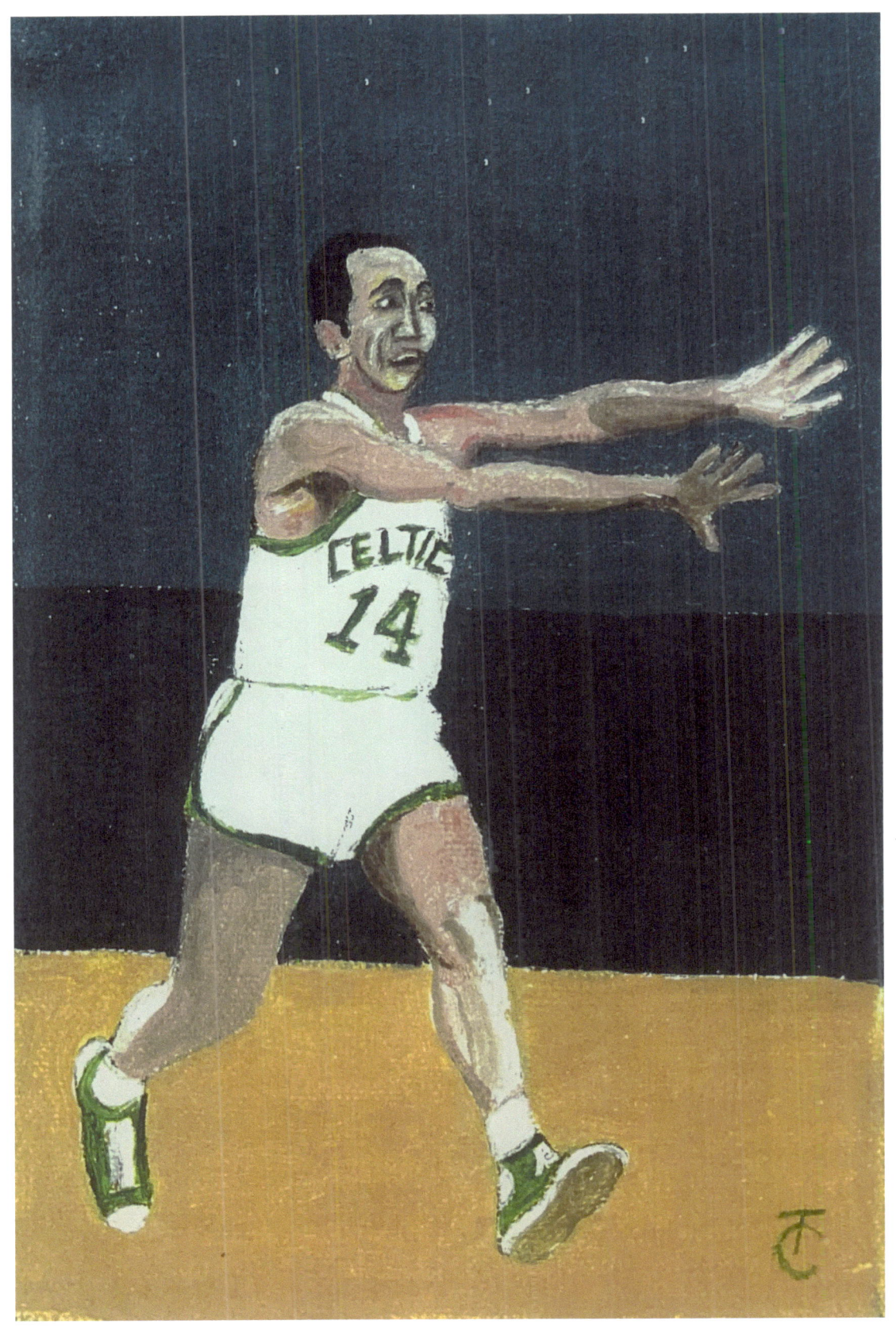

K.C. JONES

b. 1932, Taylor, TX d. 2020, CT 6 ft. 1 in. 185 lbs.

Arguably the most tenacious defensive and best team player in basketball, K.C. Jones teamed with Bill Russell to win back-to-back NCAA championships at USF (1955-56) and eight NBA titles with the Boston Celtics (1959-67). He coached various teams in the NBA and won titles twice as coach of the Boston Celtics (1983-84 and 1985-86).

K.C. Jones was the epitome of a team player in the quintessential team sport which requires each player to be skilled in all aspects of the game and to compete tirelessly.

Jones' career NBA stats are:

Points per game: 7.4
Rebounds per game: 3.5
Assists per game: 4.3

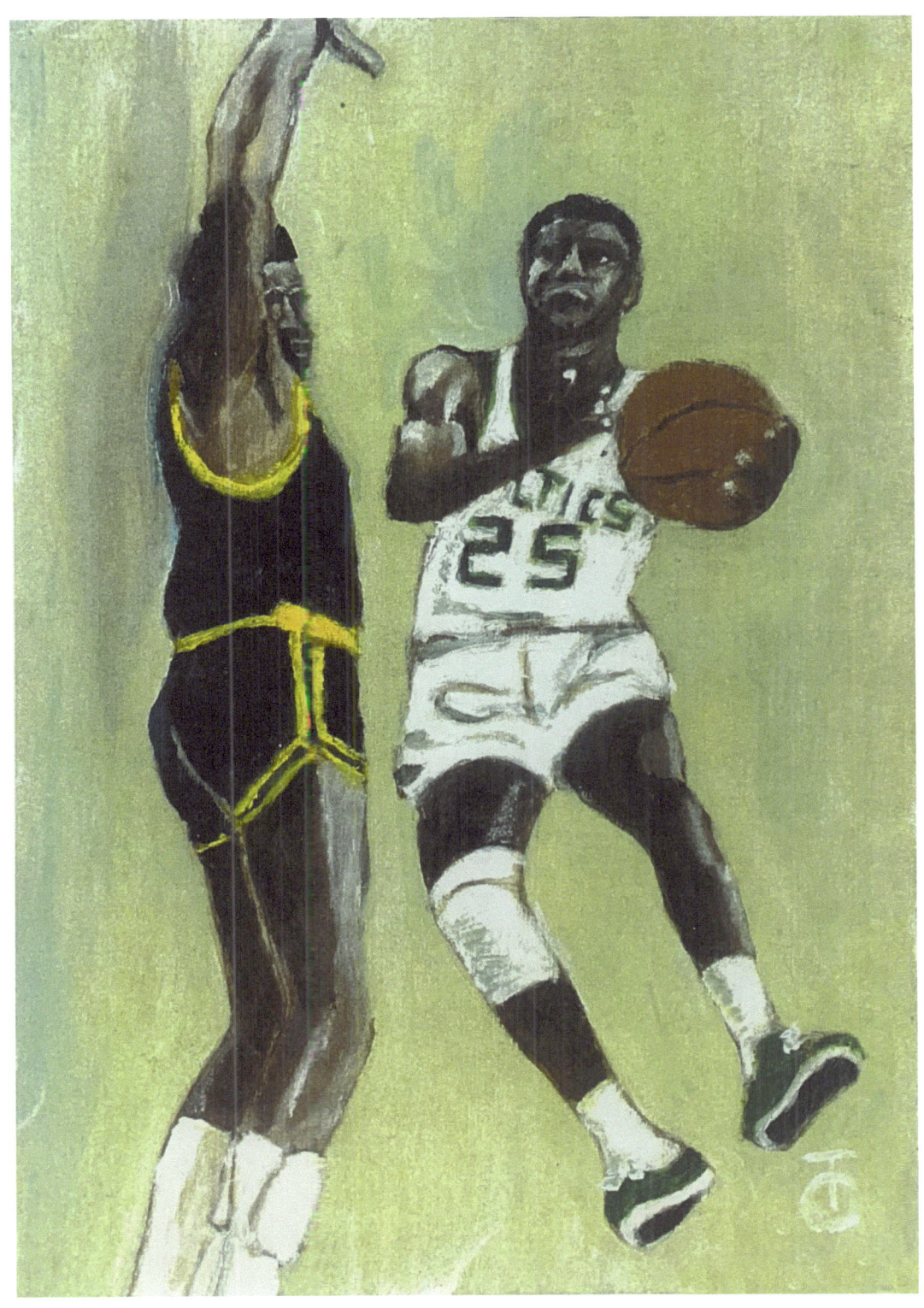

BILL RUSSELL

b. 1934, Monroe, LA 6 ft. 10 in. 220 lbs.

Bill Russell is the most valuable basketball player of all-time and probably the best. Some might say that Michael Jordan, Elgin Baylor or Oscar Robertson is the best but it is difficult to deny that honor to Russell. In college he led USF to two consecutive NCAA championships in 1955 and 1956, then captained the U.S. team to a gold medal at the 1956 Olympics in Melbourne. In the NBA, playing for the Boston Celtics from 1956 to 1969, he was a five time MVP and won eleven championships during his 13-year career. Russell won two of those championships (in 1968 and 1969) as player-coach and as the first black coach in the NBA.

The greatest NBA center before Russell and Wilt Chamberlain was George Mikan who said of Bill Russell, "Let's face it, he's the best ever. He's so good, he scares you." Bill Russell's NBA stats: only suggest his dominance on the court. In his first full NBA season he became the first player to average more than 20 rebounds per game, something he accomplished in ten of his thirteen seasons. His 51 rebounds in a single game is second only to Chamberlain's record of 55.

Bill Russell's career states are:

Points: 14,522 (15.1 ppg)
Rebounds: 21,620 (22.5 rpg) {second to Chamberlain's 23,924 {22.9 rpg}
Assists: 4,100 (4.3 apg)

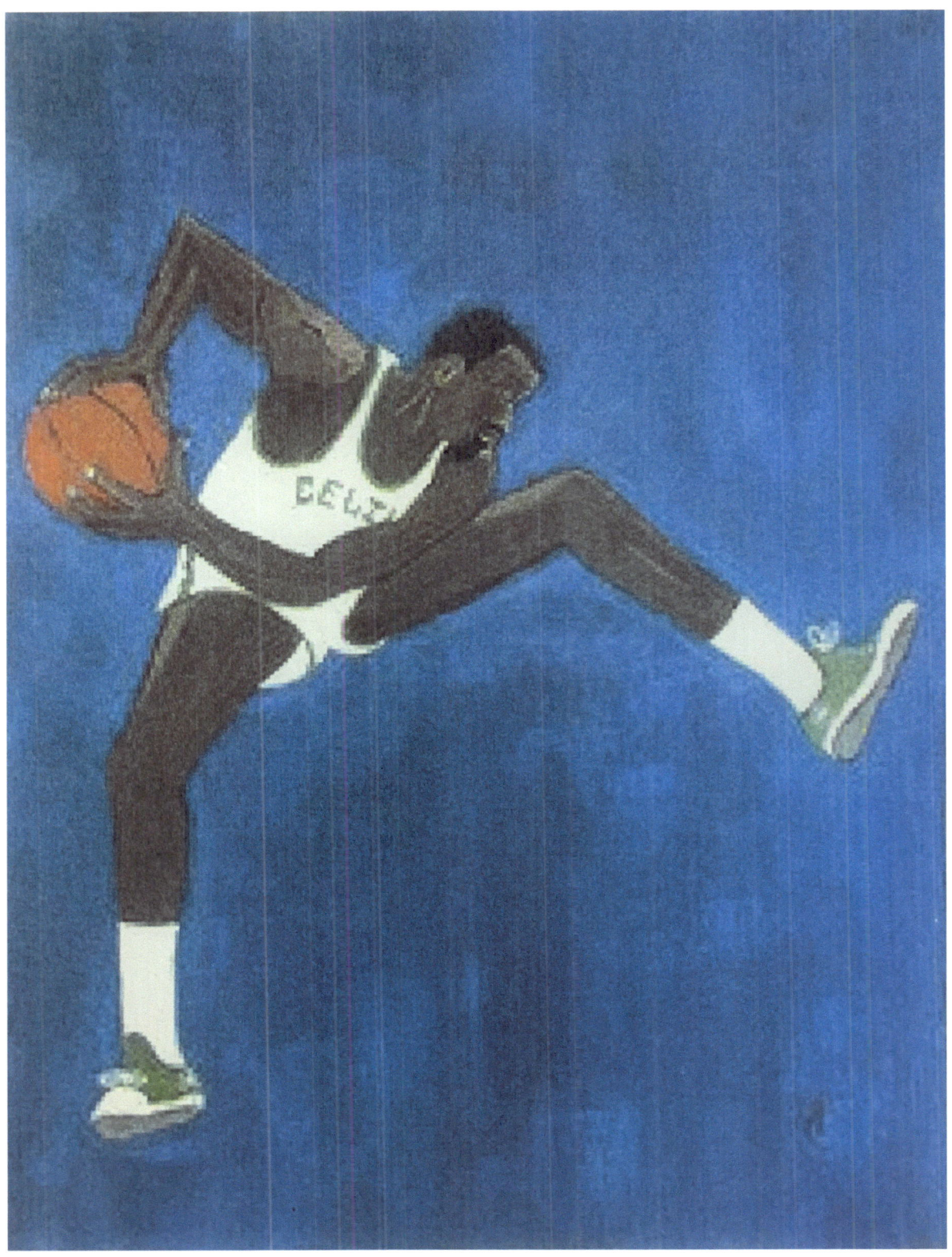

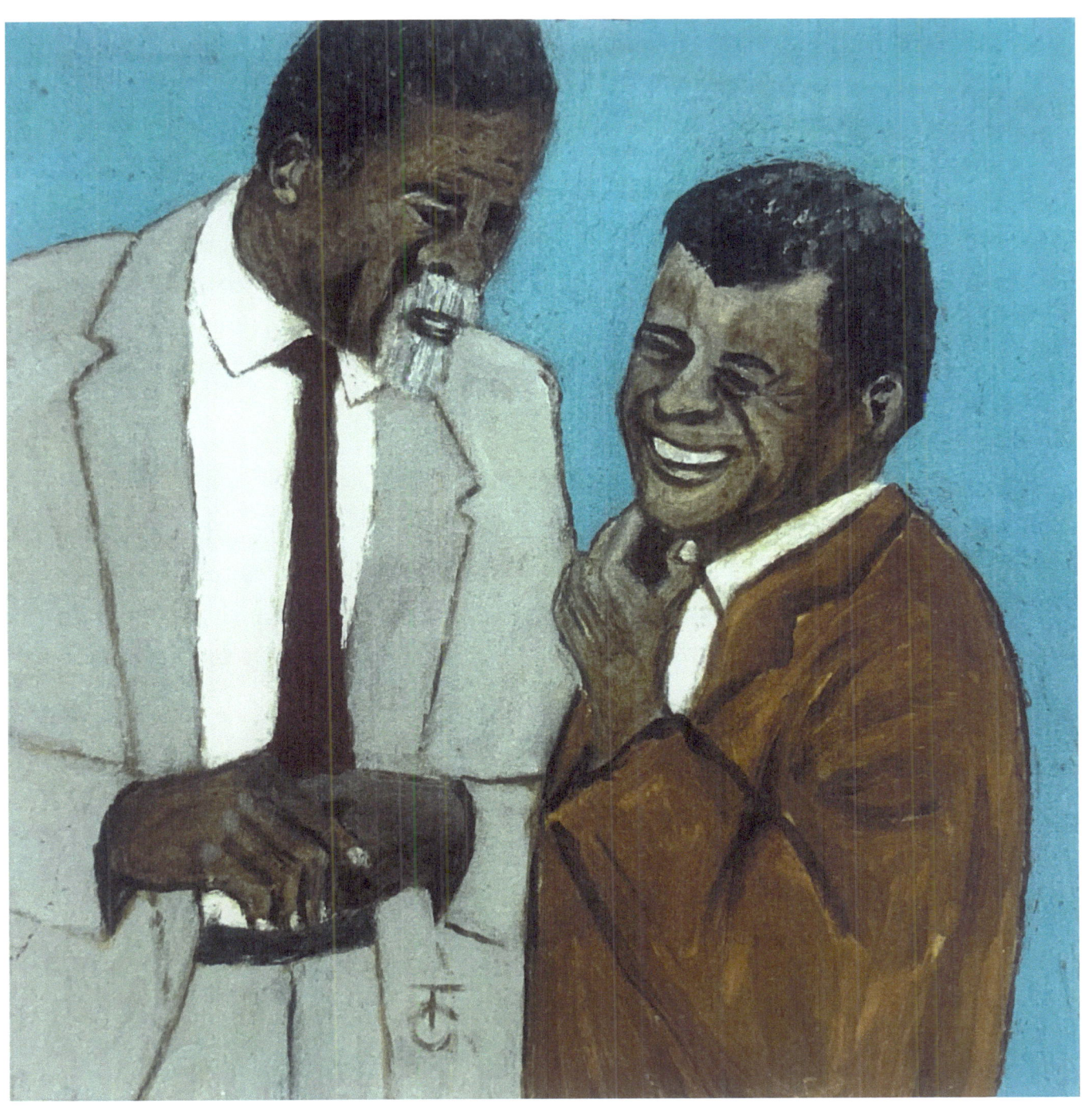

Bill Russel and KC Jones

ELGIN BAYLOR

b. 1934, Washington, D.C.　　　d. 2021, CA　6 ft. 5 in.　225 lbs.

If Elgin Baylor was not the best basketball player ever, he was the best all-around player with superb shooting, rebounding and passing skills. He was a joy to watch. He didn't start playing basketball until he was fourteen and had only limited access to public courts because of segregation in the nation's capitol city. He developed rapidly and in three seasons at the College of Idaho and Seattle University he averaged 31.3 points and 19.5 rebounds per game.

In his rookie season in the NBA in 1959 Baylor finished second in the league in scoring (24.9 ppg), third in rebounding (15.0 rpg) and eighth in assist (4.1 apg). He also scored 55 points in a single game, which at the time was the third-highest in league history behind Joe Fulks' 63 and George Mikan's 61. In the 1960-61 season points, a single game record that was not broken until 2006 when Kobe Bryant scored 81. Baylor's spectacular career stats are as follows:

Although Elgin Baylor is 27th in total career rebounds, his average of 13.5 rebounds per game is better than that of many of the top twenty-six rebounders, including Kareem Abdul Jabbar, Elvin Hayes, Moses Malone, Tim Duncan, Karl Malone, Robet Parish, Kevin Garnet, Hakeem Olajuwon, Shaquille O'Neal, Charles Barkley, Dikembe Mutombo, Dennis Rodman, Patrick Ewing and Dirk Nowitzki.

Assists:　　3,650 (4.3 apg)
Points:　　23,149 (27.4 ppg)
Rebounds:　11,463 (13.5 rpg)

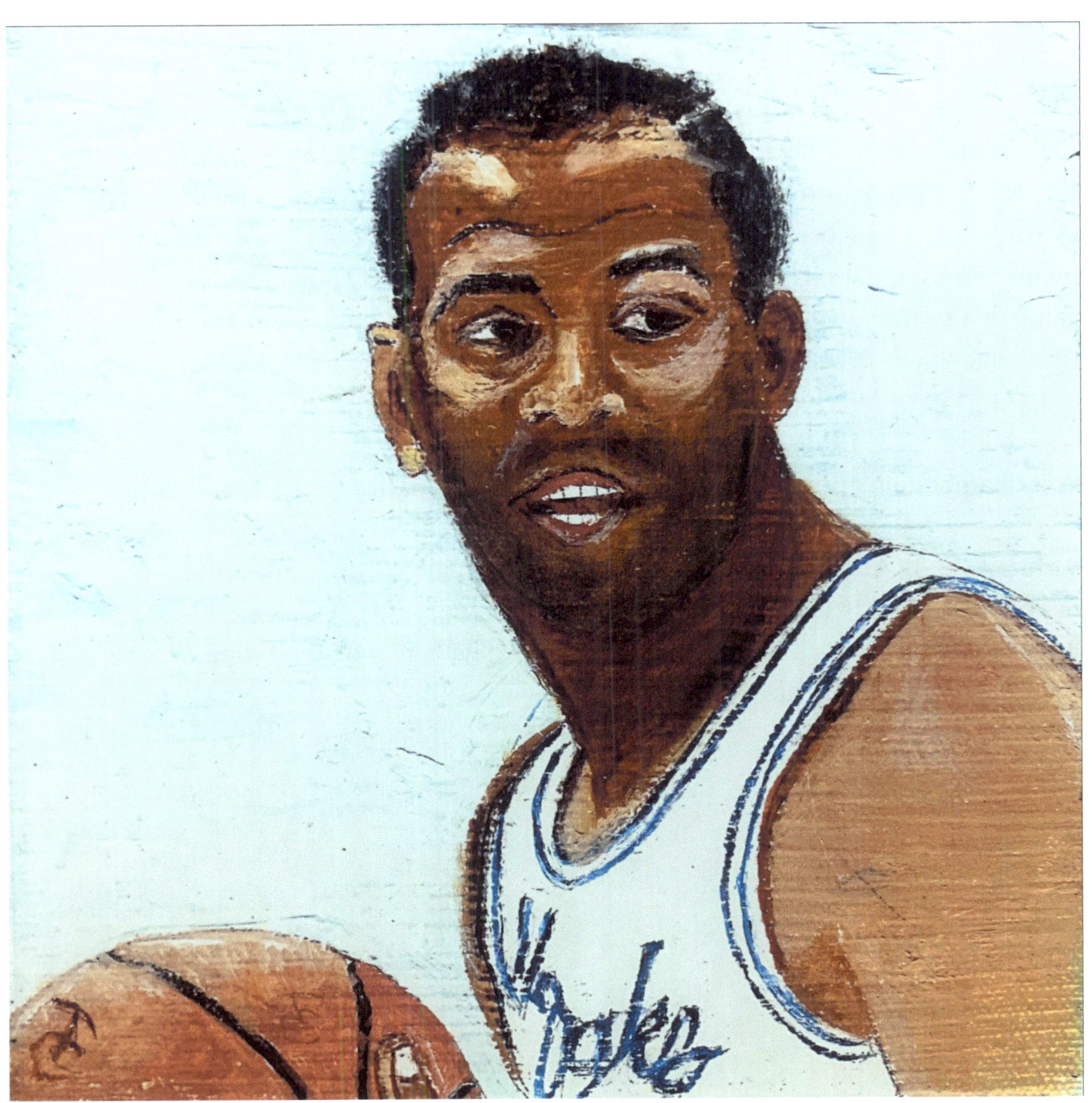

WILT CHAMBERLAIN

b. 1936, Philadelphia, PA d. 1999, Bel Air, CA 7ft. 1 in. 250 to 275 lbs.

Wilt Chamberlain was probably the first internationally renowned basketball player and the perennial rival of Bill Russell as the best "big man" of the game. Before entering the NBA in 1959 he played for the University of Kansas and the Harlem Globetrotters. He is the only player to score 100 points in a single NBA game or average more than 40 and 50 points in a season. He is the only player to average at least 30 points and 20 rebounds per game in a season, which he did seven times. He even led the NBA in assists one season. His Philadelphia 76ers won the championship in 1967 and his Los Angeles Lakers won it in 1972.

Wilt Chamberlain's prodigious offensive feats are summarized in his career stats:

Points: 31,419 (7th all-time. Average of 30.1 ppg)
Rebounds: 23, 924 (1st all-time. Average of 22.9 rpg).
Russell is 2nd with 21,620 (22.5 rpg) Jabbar is 3rd with 17,440 (11.2 rpg).
Assists: 4,643 (4.4 apg.)

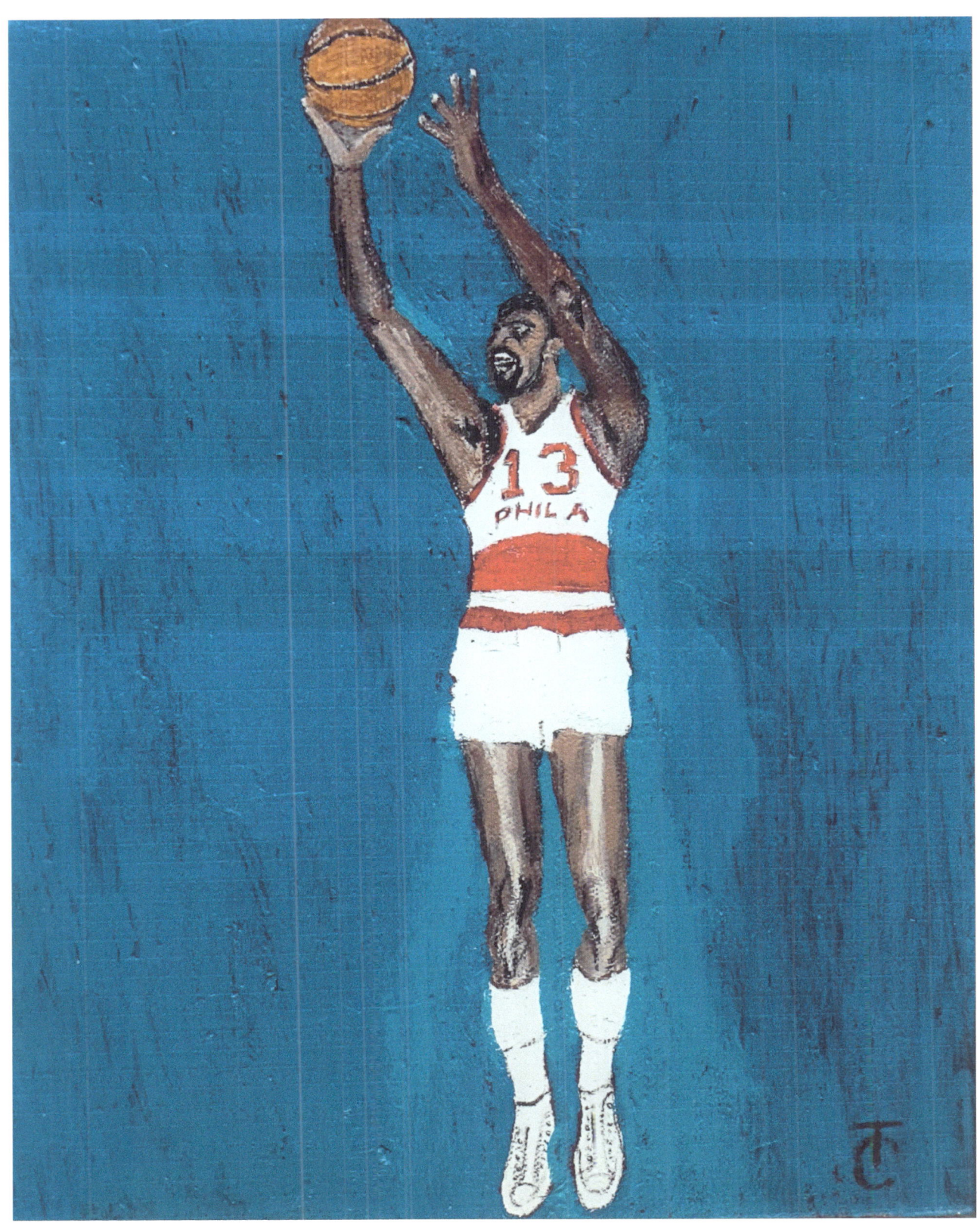

OSCAR ROBERTSON

b. 1938, Charlotte, TN 6 ft. 5 in. 205 lbs.

Oscar Robertson, perhaps the most versatile player in NBA history, was the first to average a triple-double in a season with 30.8 points, 12.5 rebounds, and 11.4 assists. His record stood for fifty years until Russell Westbrook broke it in 2021. Growing up in Indianapolis he led his high school team to two consecutive Indiana state championships and lost only one game in those two seasons. Playing for the University of Cincinnati he was thrice the national college scoring leader and named a consensus All-American. In the NBA he was an eleven-time of the All-NBA Team and led the Milwaukee Bucks to the Championship in the 1970-71 season.

Oscar Robertson's career stats are:

Points: 26, 710 (25.7 ppg) (13th best all-time)
Rebounds: 7, 804 (7.5 rpg)
Assists: 9,887 (9.5 apg)

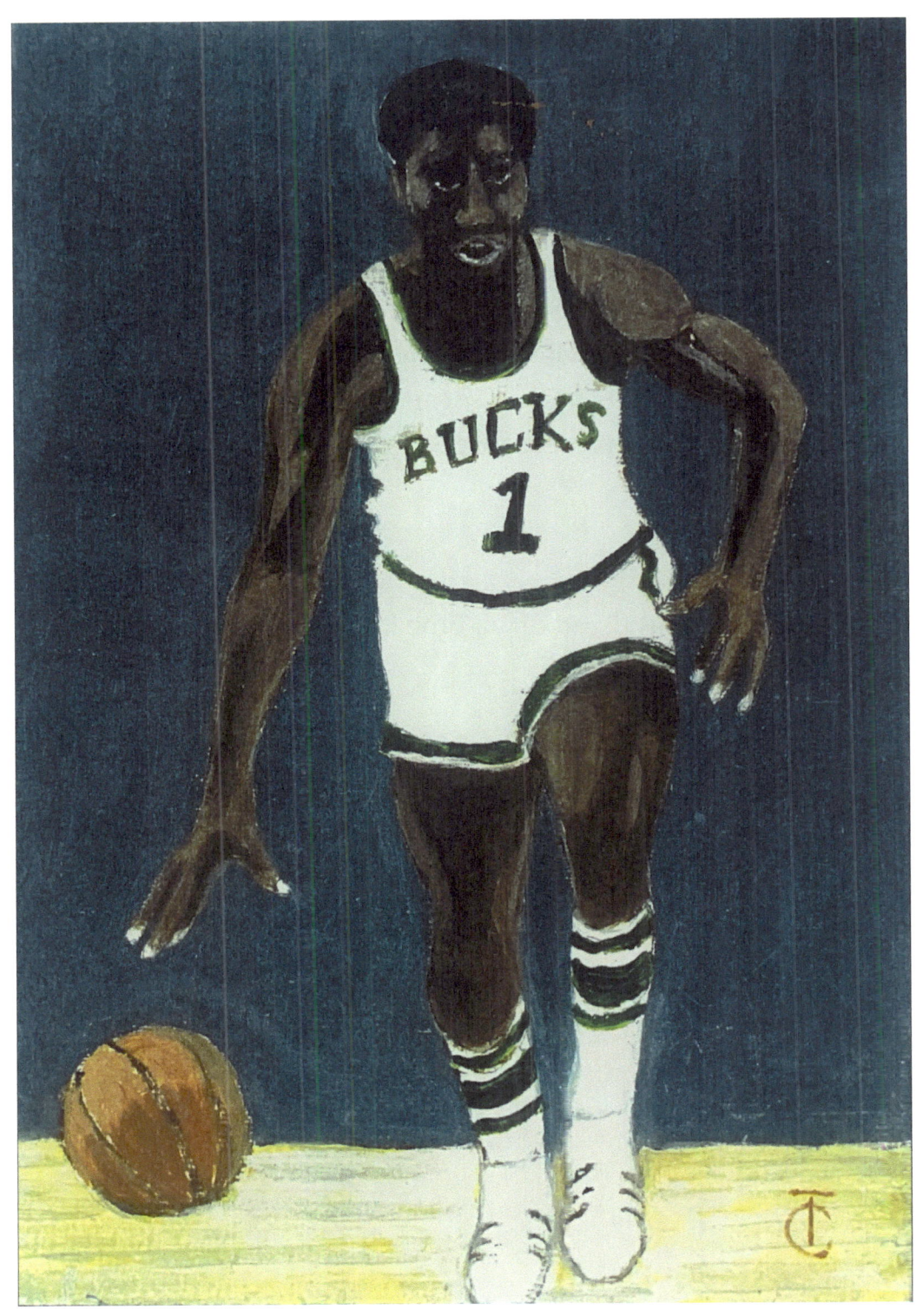

JERRY WEST

b. 1938, Chelyan, WV 6 ft. 3 in. 175 lbs.

Jerry West's image is appropriate on the corporate NBA logo because as a Los Angeles Laker, he was one of the greatest players, and as that team's general manager won six NBA titles. In college, attending the University of West Virginia he was a two-year All-American and led his team to an NCAA championship in 1959. As a pro, he was NBA Finals MVP in 1969, NBA champion in 1972, scoring champion in 1970, assists leader in 1972, and four times All-Defense Team 1970-1973. In his second year as a Laker, 1962, before there was a three-point shooting/scoring, West scored 63 points against the Knicks.

Jerry West's career stats are:

Points: 25, 192 (270 ppg) (22nd on all-time list)
Rebounds: 5,366 (5.8 rpg)
Assists: 6, 238 (6.7 apg)

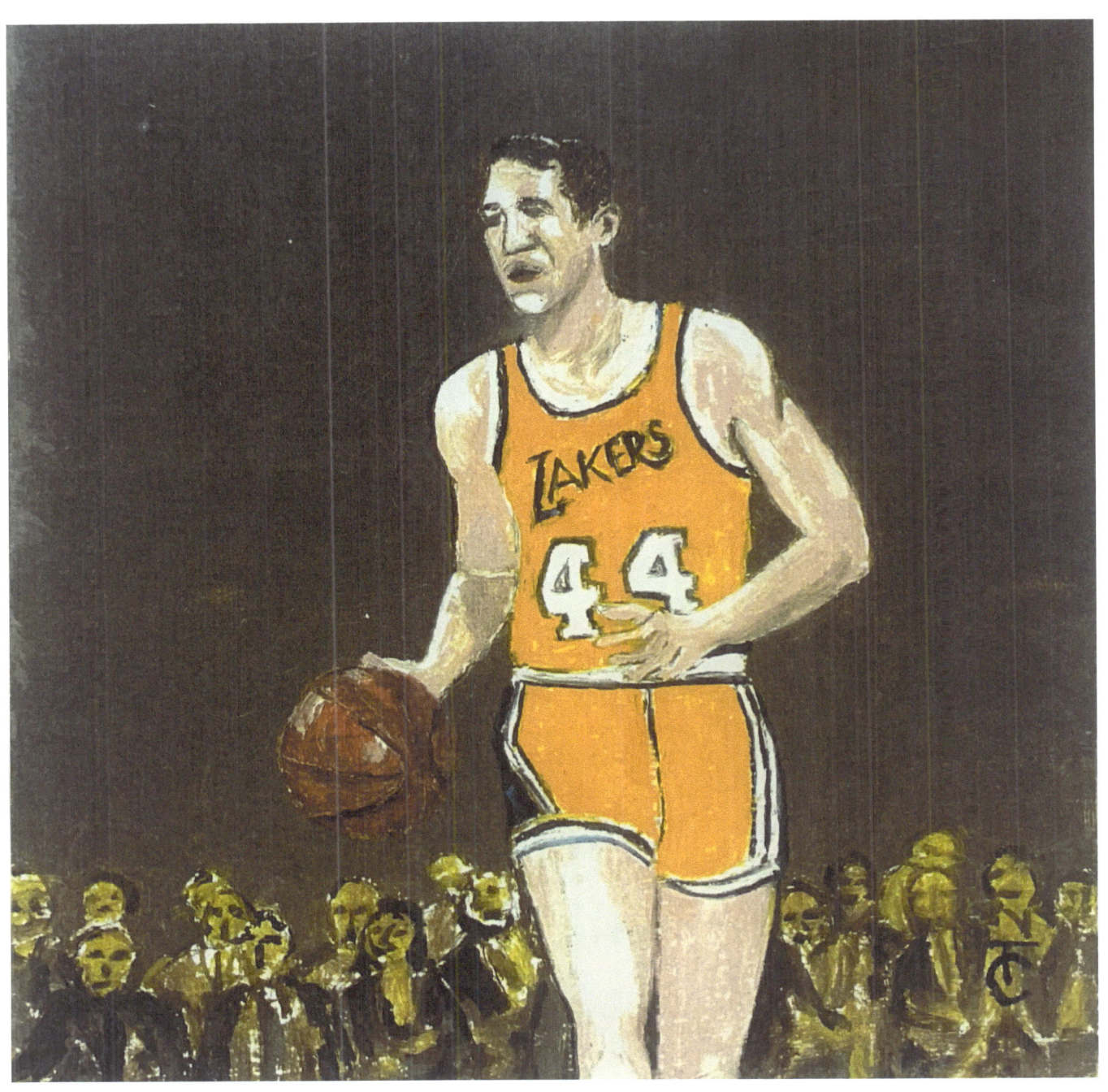

PAUL NEUMANN

b. 1938, New Port Beach, CA 6 ft. 1 in. 175 lbs.

Paul Neumann was the ideal basketball player who could run, jump, shoot, rebound, pass, dribble and drive equally well to left or right, and never, in my experience, turned the ball over. He was also a superb defender. In his senior year at Stanford, his team first upset USF, rated number 1 in the country at the time, then became last team to defeat the University of California before it won the 1959 NCAA championship. Pete Newell, the celebrated Cal coach said that Neumann was not only the best player in the Pacific Coast Conference but in all the West.

In a famous NBA trade, Neumann, Connie Dierking, and Lee Shaffer were traded by the Philadelphia 76ers to the San Fransisco Warriors for Wilt Chamberlain.

Neumann's six-year career NBA stats are:

Points: 4, 989 (11.0 ppg)
Rebounds: 1, 318 (2.9 rpg)
Assists: 1, 453 (3.2 apg)

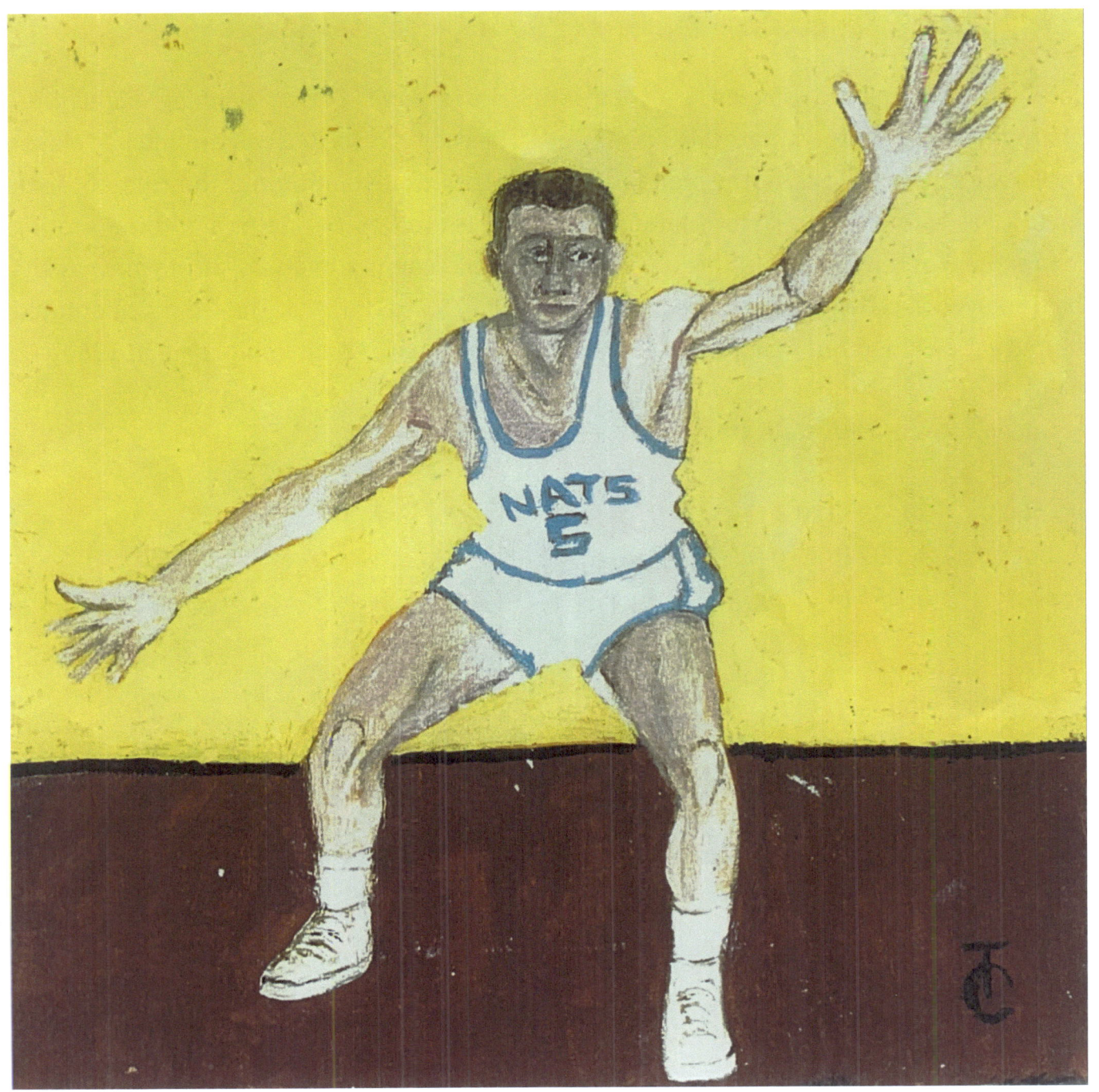

JOHN HAVLICEK

b. 1940, Martins Ferry, OH,	d. 2019, Jupiter, FL	6 ft. 5 in. 203 lbs.

John Havlicek played sixteen seasons with the Boston Celtics winning eight NBA championships. His teammate Bill Russell said. "Havlicek was the best all-around ball player (he) ever saw." Havlicek both small forward and guard, revolutionized the role of "sixth man", was a four-time all-NBA defenseman, and retired as the Celtic's all-time scoring leader. He was remarkable for his stamina, hustle, and competitiveness, all of which assets he displayed in college when as a sophomore at Ohio State University he led his celebrated team that included Jerry Lucas and Larry Seigfred to the NCAA championship in 1960.

Havlicek's career NBA stats are:

Points: 26, 395 (20.8 ppg) (17th best all-time)
Rebounds: 8, 007 (6.8 rpg)
Assists: 6, 114 (4.8 apg)

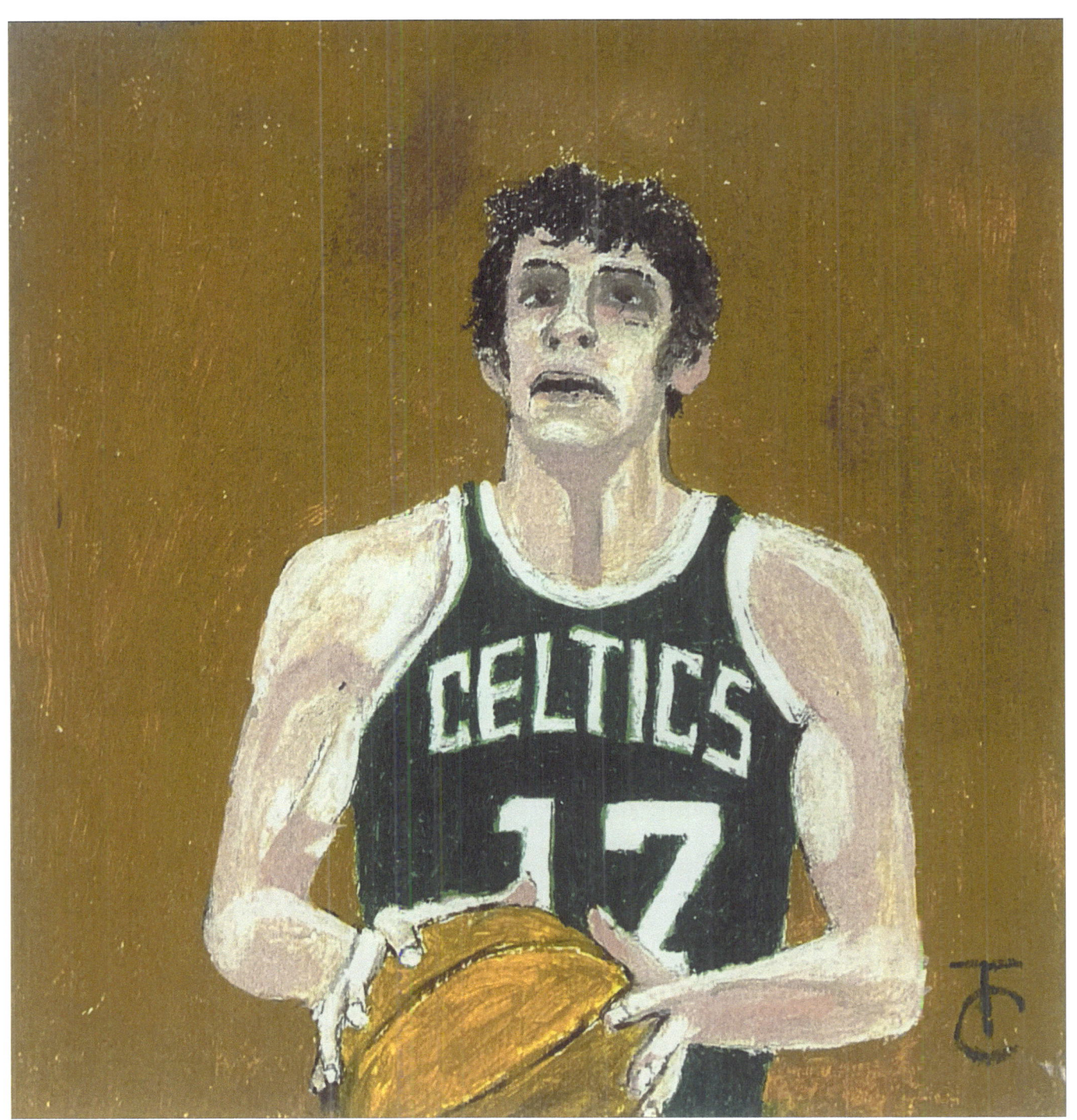

BILL BRADLEY

b. 1943, Crystal City, MO 6 ft. 5 in. 205 lbs.

Bill Bradley played ten seasons with the New York Knicks and is in the NBA Hall of Fame. His accomplishments, both before and after pro basketball, are also spectacular. In his freshman year at Princeton in 1961, he averaged 30 points per game and at one point made 57 consecutive free throws, a record not yet broken. In his final year at Princeton, he averaged 30.2 ppg and scored 58 points against Wichita State in the consolation game of the NCAA tournament and was chosen MVP. That same year he was awarded the Sullivan Award as United States best amateur athlete. In 1964 Bradley was unanimously selected to join the U.S. Olympic basketball team and won a gold medal at the Tokyo Olympics. After two years of study as a Rhodes Scholar at Oxford, he entered the NBA. Bill Bradley's Knicks with Walt Frazier, Dave DeBusschere, Earl Monroe, and Willis Reed won the NBA championships twice, in 1971 and 1973.

Bradley's career stats, playing the small forward position are:

Points: 9, 217 (12.4 ppg)
Rebounds: 2, 354 (3.2 rpg)
Assists: 2, 533 (3.4 apg)

After his basketball career Bradley became a three-term U.S. Senator from New Jersey. In 2000, he ran unsuccessfully as a Democratic presidential nominee. Bradley is the subject of A Sense of Where You Are by John McPhee, probably the best book about a basketball player ever written.

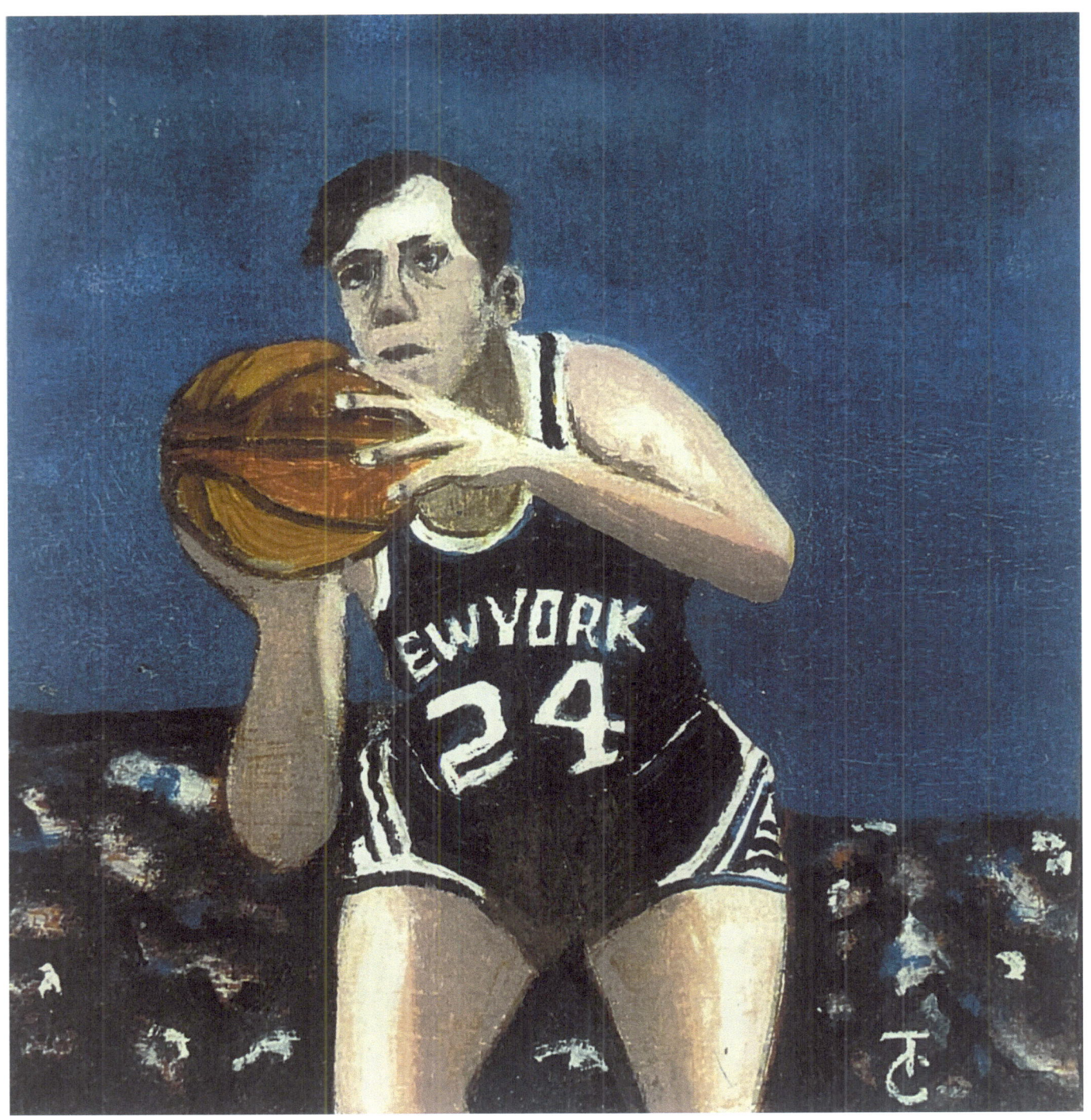

KAREEM ABDUL-JABBAR (born LEW ALCINDOR)

b. 1947, New York, NY 7 ft. 2 in. 225 lbs.

Lew Alcindor was probably the first nationally renowned high school basketball player. He went from New York City to the West Coast and led UCLA to three consecutive NCAA championships (1966-1969). In the NBA he played six seasons with the Milwaukee Bucks, winning a championship in 1971, after which he took the Muslim name Kareem Abdul-Jabbar. He was traded to the Los Angeles Lakers in 1975 with whom he won five more championships in fourteen seasons. At the time of his retirement in 1989, he was remarkably, the NBA's leader in points scored (38, 387), games played (1, 560), minutes played (57, 446), field goals made (15, 837), field goals attempts (28, 307), blocked shots (3, 189), and defensive rebounds (9, 394).

Kareem Abdul-Jabbar's career stats are:

Points: 38, 387 (24.6 ppg) (1st all-time)
Rebounds: 17, 440 (11.2 rpg) (3rd all-time)
Assists: 5, 660 (3.6 apg)

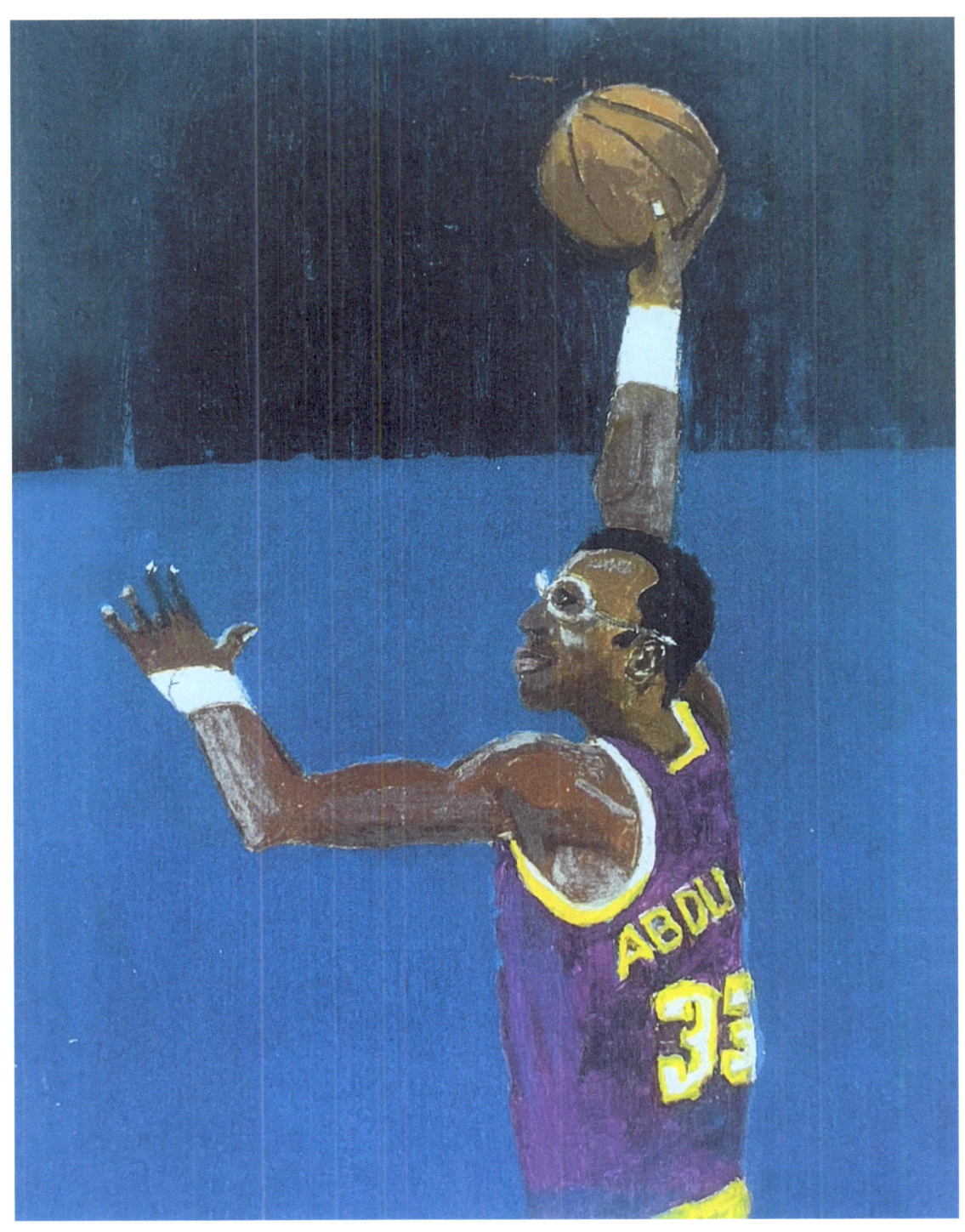

LARRY BIRD

b. 1956, West Baden Springs, IN 6 ft. 9 in. 220 lbs.

Larry Bird grew up in French Lick, Indiana and after a phenomenal high school and college playing career at small Indiana State University which he led the NCAA finals, he joined the Boston Celtics, for whom he played thirteen seasons. A superb shooter and passer who could play both inside and outside he has been rated by more than one panel of experts the greatest small forward of all time. Bird was a 12-time NBA All-Star and received the NBA MVP award three consecutive times (1984-1986). He led the Celtics to three NBA championships (1981, 1984, and 1986).

Larry Bird's career stats are:

Points: 21, 791 (24.3)
Rebounds: 8, 974 (10.0)
Assists: 5, 695 (6.3)

EARVIN "MAGIC" JOHNSON

b. 1959, Lansing, MI 6 ft. 9 in. 220 lbs.

Magic Johnson led Michigan State University to the NCAA championships over Larry Bird's Indiana State team in 1979. Thereafter, they were linked as rivals in the NBA, Magic with the Los Angeles Lakers and Bird with the Boston Celtics. During their competitive years, the Lakers won five championships and the Celtics three. Magic was three times the NBA finals MVP and Bird was twice MVP. Johnson was probably the most effective big man to ever play point guard, though he seemed not to dribble the ball properly but to carry it.

Magic Johnson's career stats in thirteen seasons are:

Points: 17,707 (19,5 ppg)
Rebounds: 6, 559 (7.2 rpg)
Assists: 10, 141 (11.2)

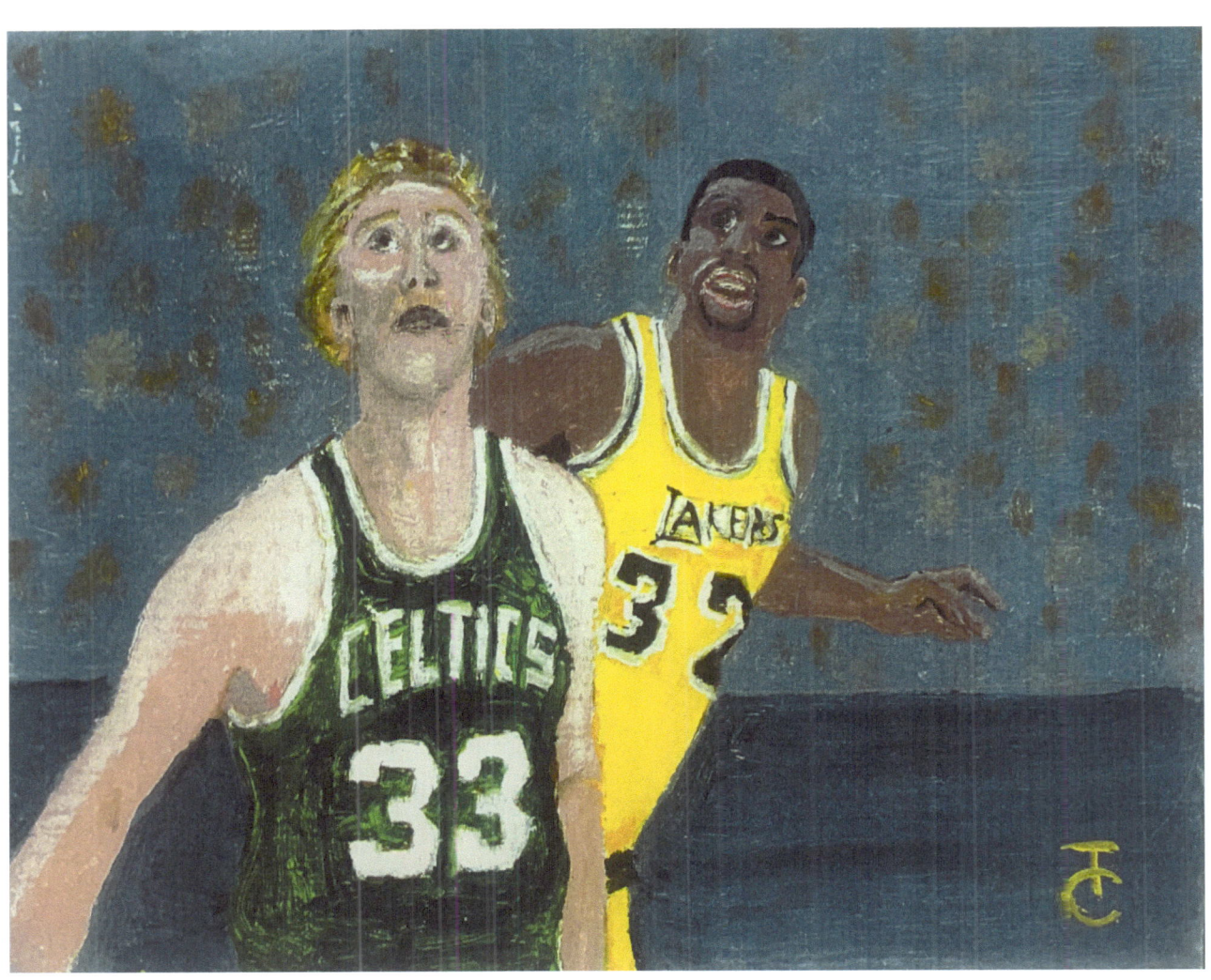

CLYDE DREXLER

b. 1962, New Orleans, LA 6ft. 7 in. 222 lbs.

Clyde Drexler was nicknamed "Clyde the Glide" because of the grace and ease with which he played, as anyone who saw him could attest. He grew up in Houston and played college basketball at Houston before joining the Portland Trail Blazers in the NBA and then finished his career back in Houston with the Rockets. Drexler was a good scorer (number 32 on the NBA all-time list), a superb defender league-leading stealer, and possibly the greatest dunker of all. He led the Rockets to an NBA championship in 1995, was a ten-time NBA AllStar.

Clyde Drexler's career stats are:

Points: 22, 195 (20.4 ppg)
Rebounds: 6, 667 (6.1 rpg)
Assists: 6, 125 (5.6 apg)

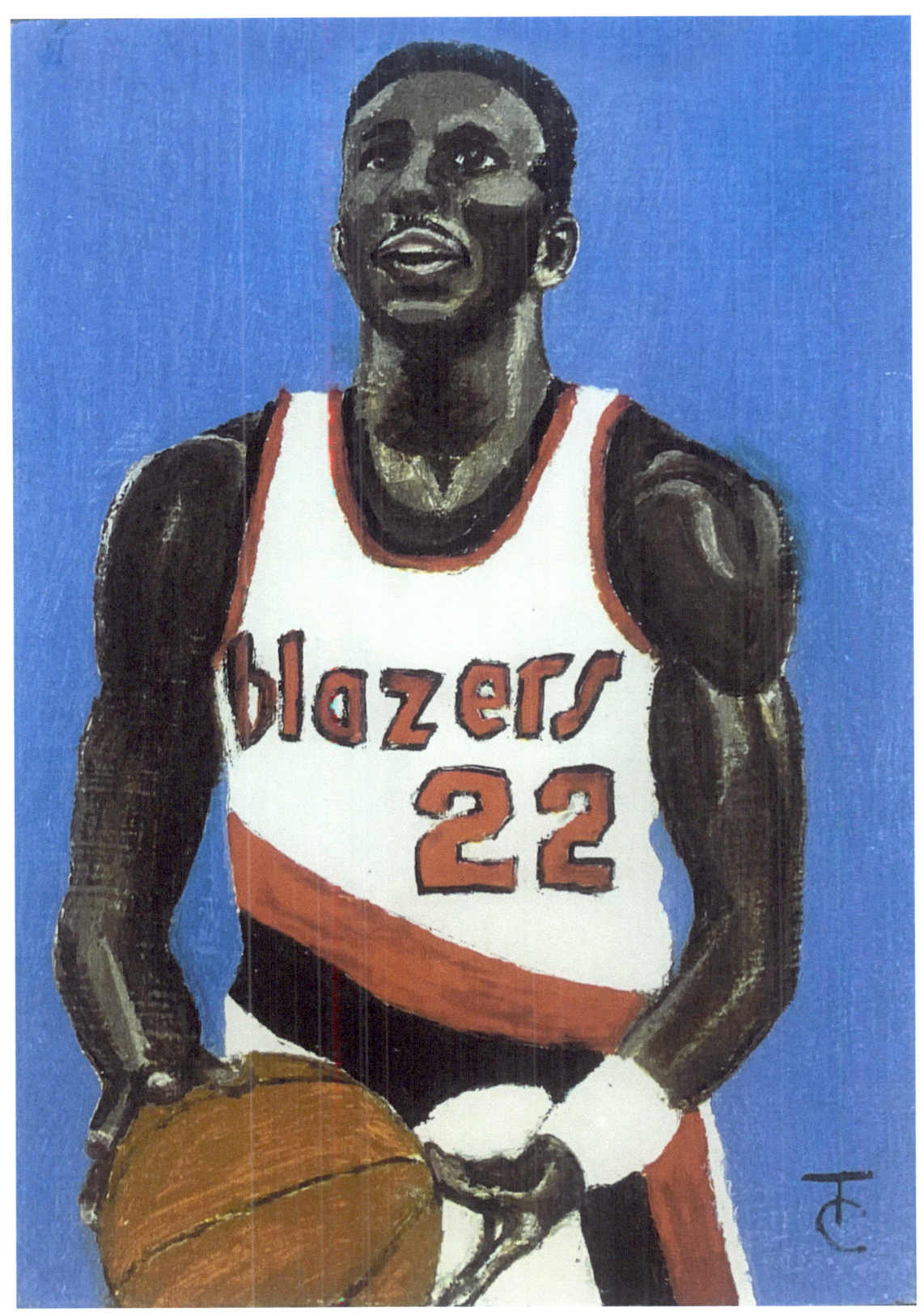

JOHN STOCKTON,

b. 1962, Spokane, WA 6ft.1 in. 175 lbs.

John Stockton, the NBA's northwest region superstar, was born and bred in Spokane, attended Gonzaga, and played nineteen seasons with the Utah Jazz. He holds the NBA record for the most career assists (15,806) and steals (3,265). Stockton, the ideal playmaker and teammate Karl Malone (2nd leading scorer all-time) are widely considered to be the best pick-and-roll combination ever. He was an NBA All-Star ten times but his and Malone's Jazz failed to win the championship in all but two chances, (1991 and 1998).

John Stockton's career stats are:

Points: 19,711 (13.1 ppg)
Assists: 15,806 (10.5)
Steals: 3,265 (2.2 spg)

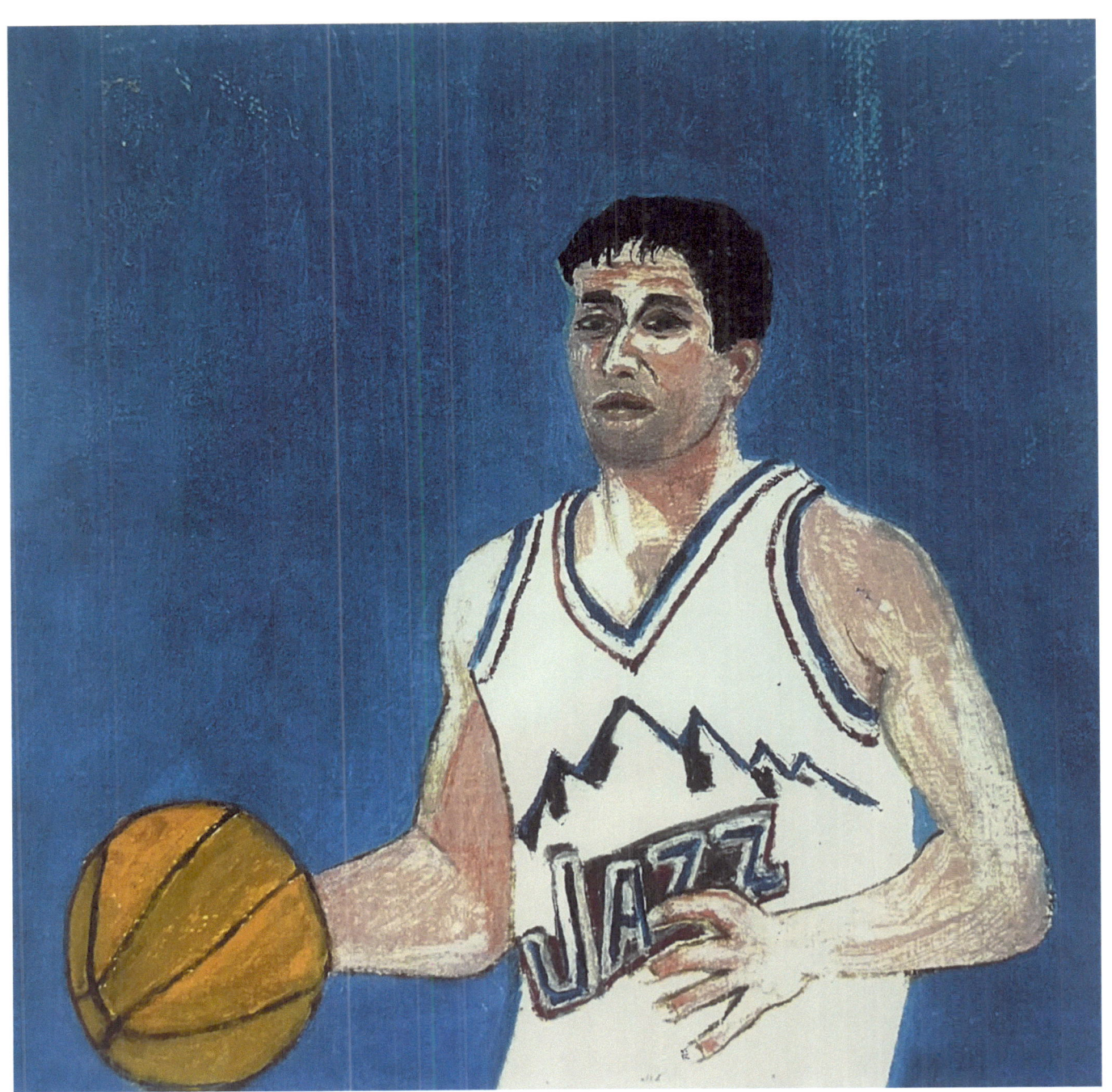

KARL MALONE

b. 1963, Summerfield, LA 6ft. 9 in. 259 lbs.

After attending Louisiana Tech University, Karl Malone was the 13th overall NBA draft pick in 1985. In eighteen spectacular seasons with the Utah Jazz, he ended his career as the second-leading scorer in the NBA behind Kareen Abdul-Jabbar and the seventh-leading rebounder. With eleven first-team all-NBA selections, Malone is tied for second place with Kobe Bryant behind the leader, LeBron James.

Karl Malone's NBA stats are:

Points: 36, 928 (25.0 ppg) (2nd all-time)
Rebounds: 14, 968 (10.1 rpg) (7th all-time)
Assists: 5, 238 (3.6 apg)

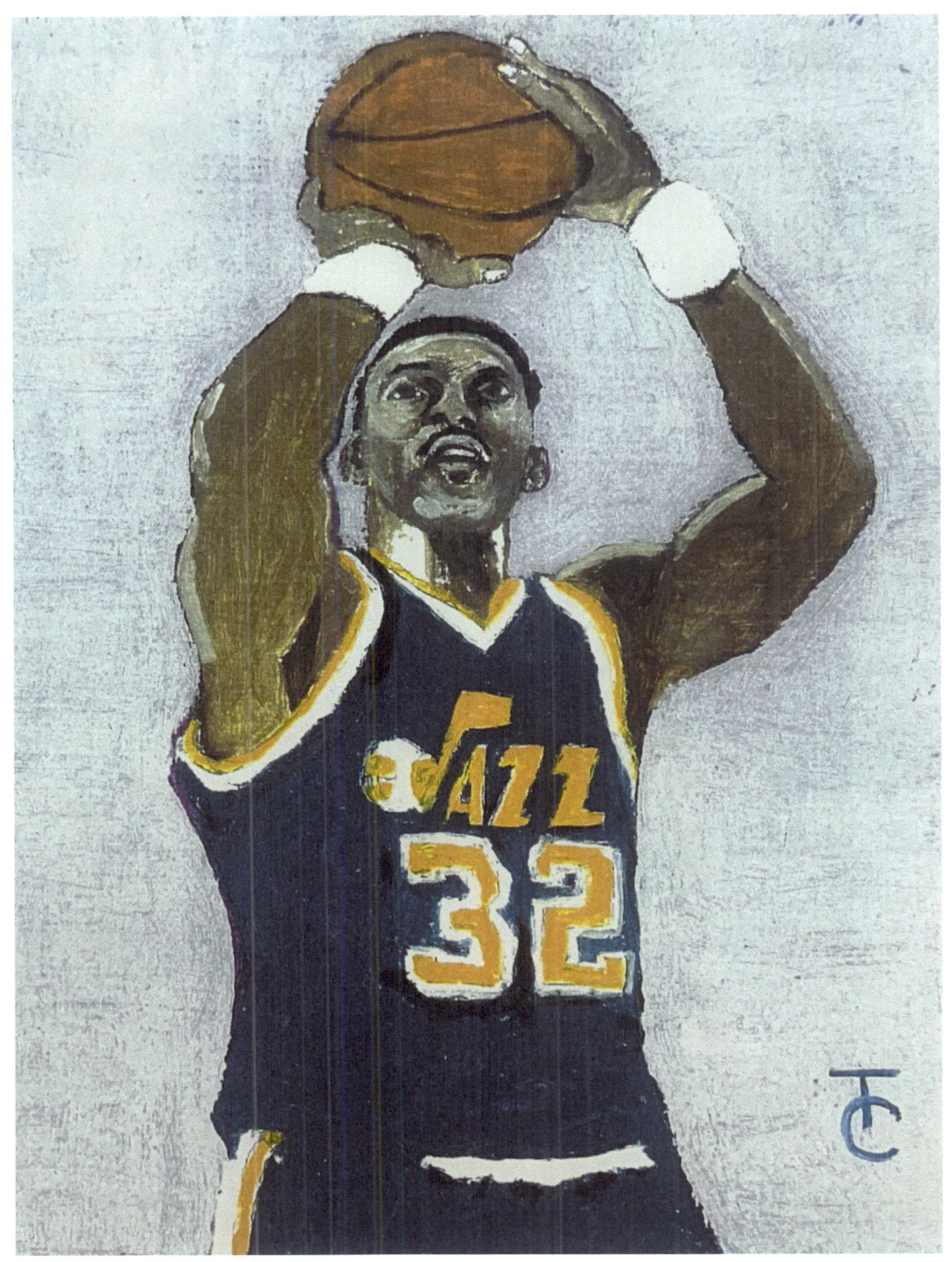

HAKEEM OLAJUWON

b. 1963, Lagos, Nigeria 7 ft. 0 in. 255 lbs.

Hakeem Olajuwon is the greatest basketball player born on the African continent. He emigrated from Nigeria to play basketball at the University of Houston. He led his teams to two consecutive championships but lost both while Olajuwon became the only player from the losing side to win the MVP. In 1984 Olajuwon was selected for the NBA draft over superstars, Micheal Jordan, Charles Barkley, and John Stockton. Olajuwon twice led the NBA in rebounds and three times in blocks. He was twice NBA Defensive Player of the Year and twelve times NBA All Star.

Hakeem Olajuwon's career stats are:

Points: 26, 946 (21.8 ppg) (12TH BEST ALL-TIME)
Rebounds: 13, 747 (11.1 rpg) (14TH All-Time)
Assists: 3, 830 (3.1 bpg)

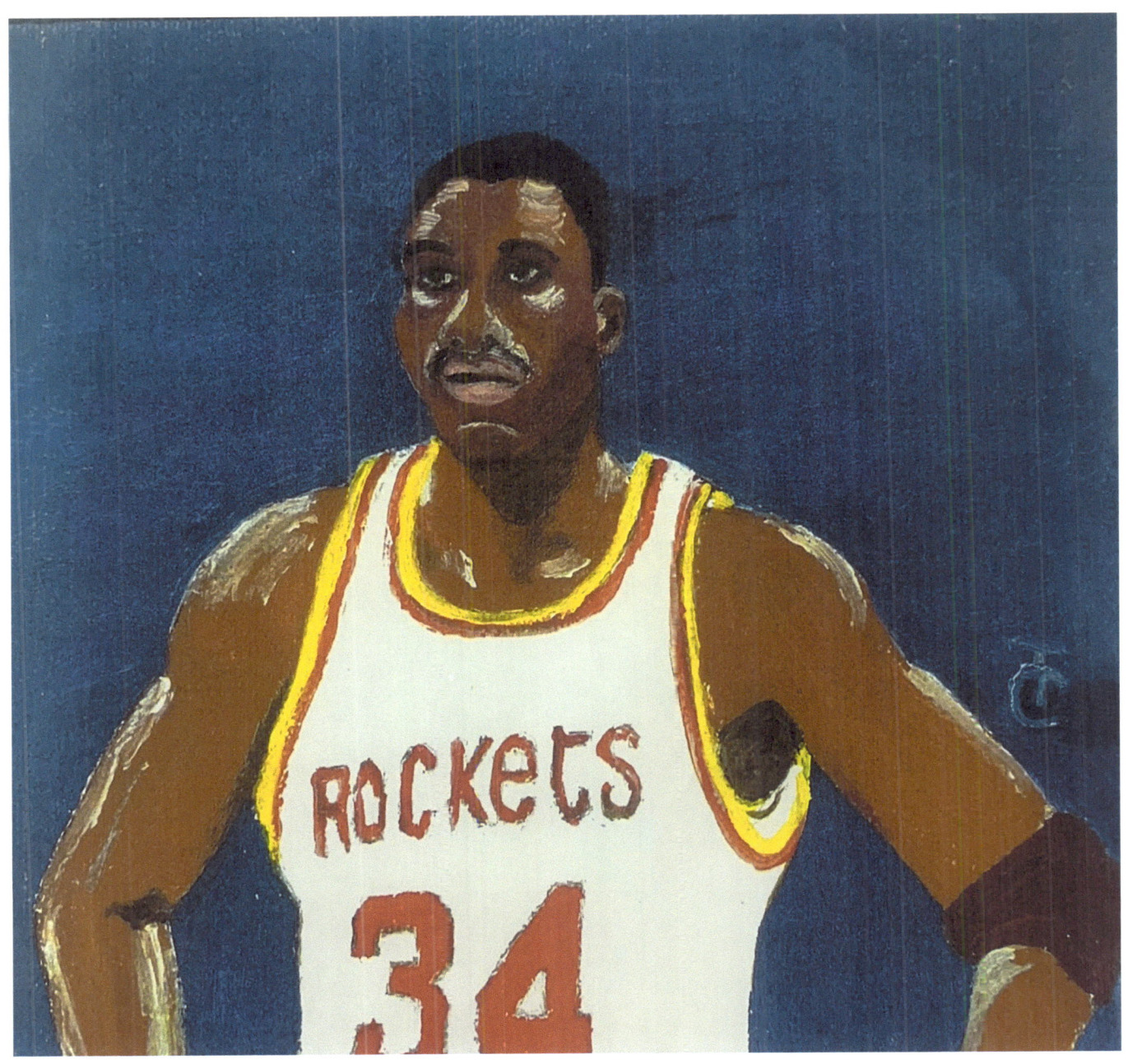

MICHAEL JORDAN

b. 1963, Brooklyn, NY 6 ft. 6 in. 216 lbs.

Michael Jordan is widely acclaimed as the greatest basketball player ever, just as George Mikan was known to many Americans in 1950 as Mr. Basketball, so Michael Jordan is known to many people around the world today as Mr. Basketball. His stature is such that the Associated Press named Jordan second only to Babe Ruth as the century's best athlete.

Jordan played for the University of North Carolina before signing with the Chicago Bulls in 1984. In his rookie season, he averaged 28.2 ppg on 51.5% shooting. He played twelve seasons with the Bulls, interrupted by a two-year interlude to play minor league baseball. During that span, Jordan twice led the Bulls to three-peat championships (1991-1993) and (1995-1998). Jordan's phenomenal leaping ability was used to create and perfect the flying slam dunk from the free throw line. He was a superlative defensive player.

Points: 32, 292 (30.1 ppg) (5TH Best All-time)
Rebounds: 6, 676 (6.2 rpg)
Assists: 5, 633 (5.3 bpg)

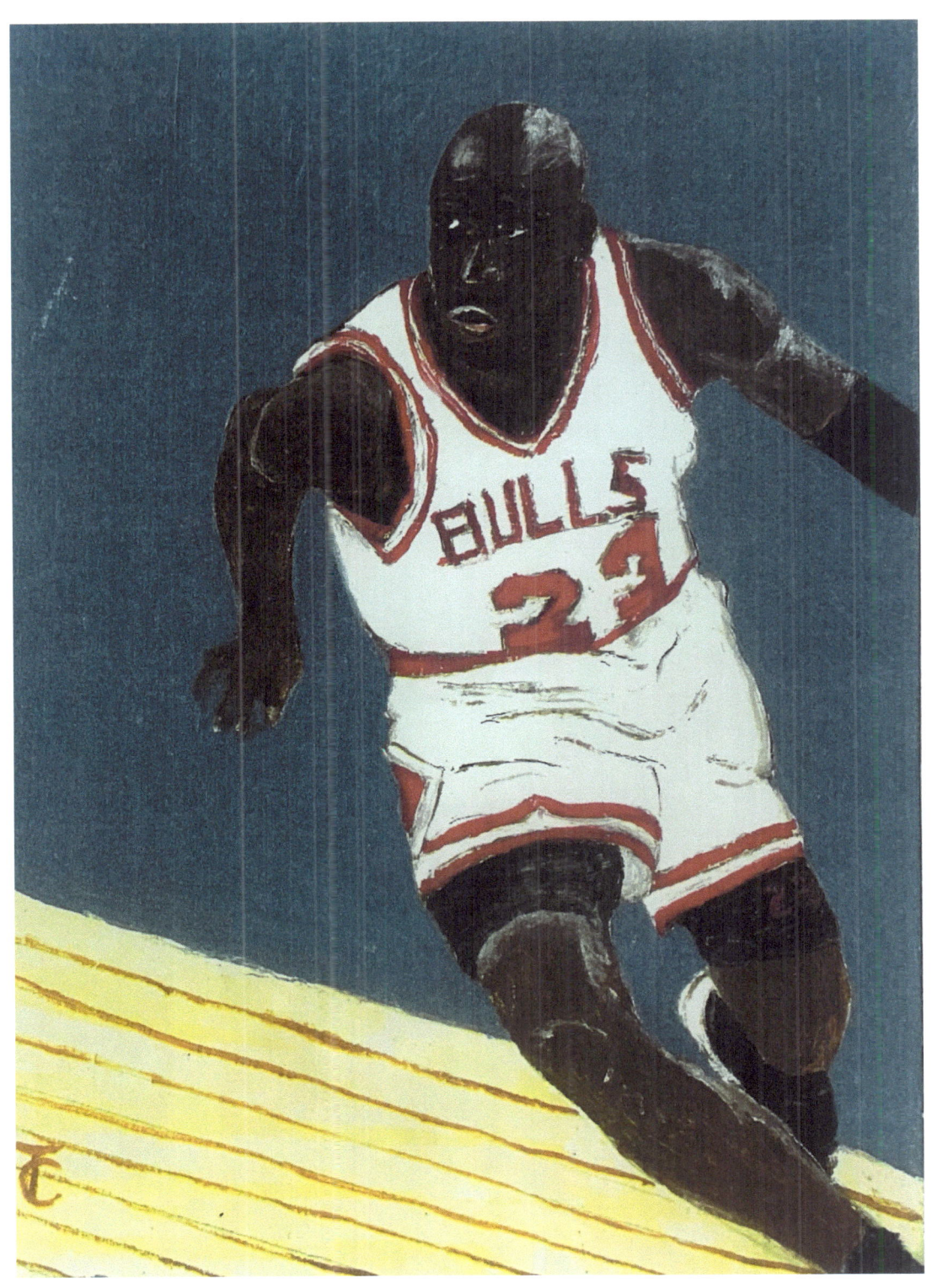

JASON KIDD

b.1973, San Fransisco, CA 6 ft. 4 in. 210 lbs.

Jason Kidd had an extraordinary high school career in Alameda and then in college at the University of California, Berkeley before turning pro in 1994. A point guard with exceptional ability to pass and rebound made Kidd a regular triple-doubles threat. His NBA career triple-doubles total was 107. Playing nineteen seasons for the Mavericks, Sun, Nets, and Knicks, Kidd ranks second on the NBA all-time lists in career assists and steals and ninth in 3-point field goals made. He won an NBA championship with the Dallas Mavericks in 2011 and was honored five times on the all-NBA First Team and four times on the NBA All-Defensive First Team.

Jason Kidd's career stats are:

Points: 17, 529 (ppg)
Rebounds: 8, 725 (6.3 rpg)
Steals: 12, 091 (8.7 apg)

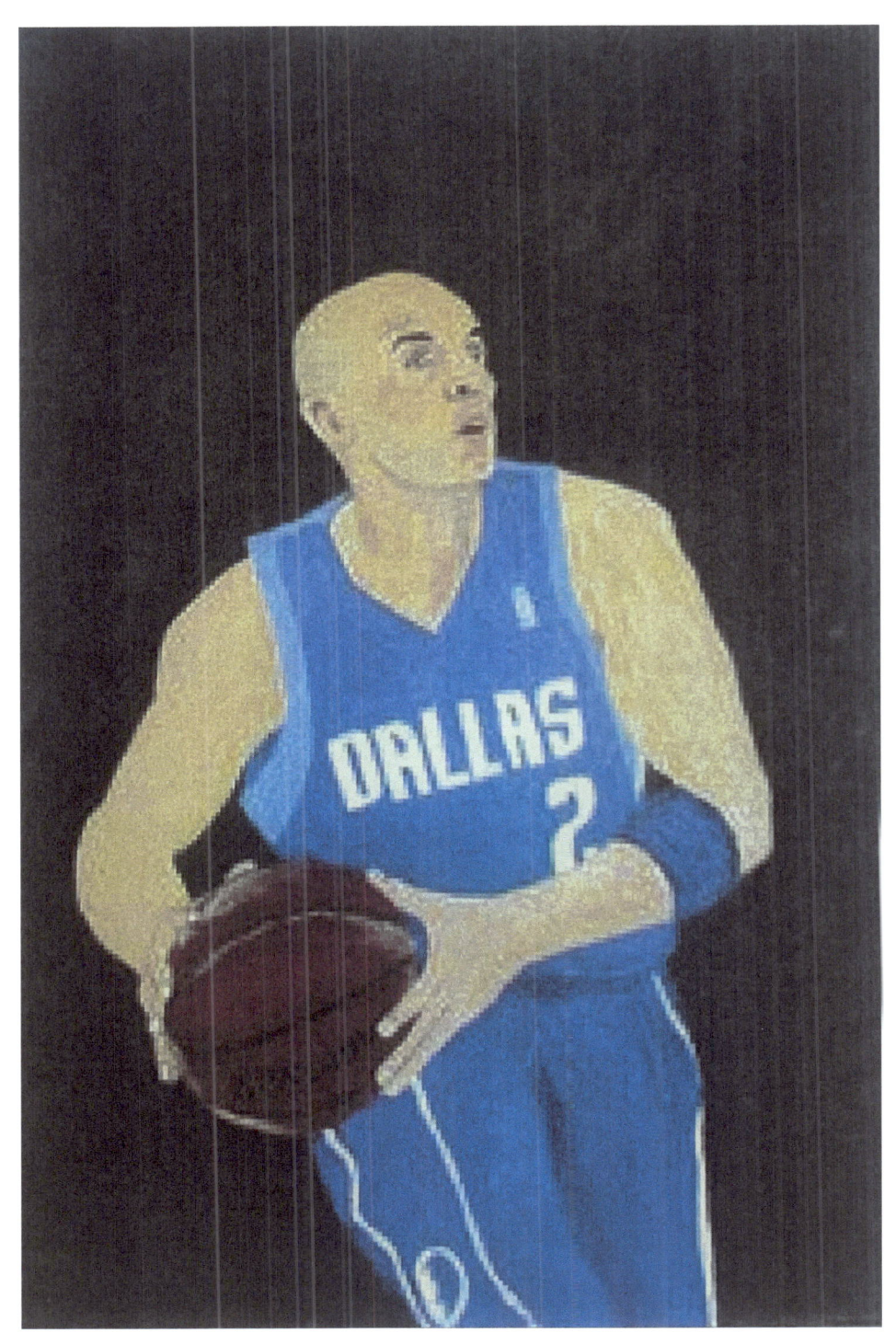

TIM DUNCAN

b.1976, Saint Croix, U.S. Virgin Islands 6 ft. 11 in. 250 lbs.

Tim Duncan, the greatest West Indian basketball player ever, is demonstrably the best power forward in NBA history. After a four-year college career at Wake Forest University, Duncan played nineteen seasons with the San Antonio Spurs winning five NBA championships. He was thrice the NBA finals MVP (1999, 2003, 2005); ten-time all-NBA First Team, and eight times NBA All-Defensive First Team.

Tim Duncan's career stats are:

Points: 26, 496 (19.0 ppg) (15th highest all-time)
Rebounds: 15, 091 (10.8 rpg) (6th best all-time)
Assists: 4, 225 (3.0 (apg)

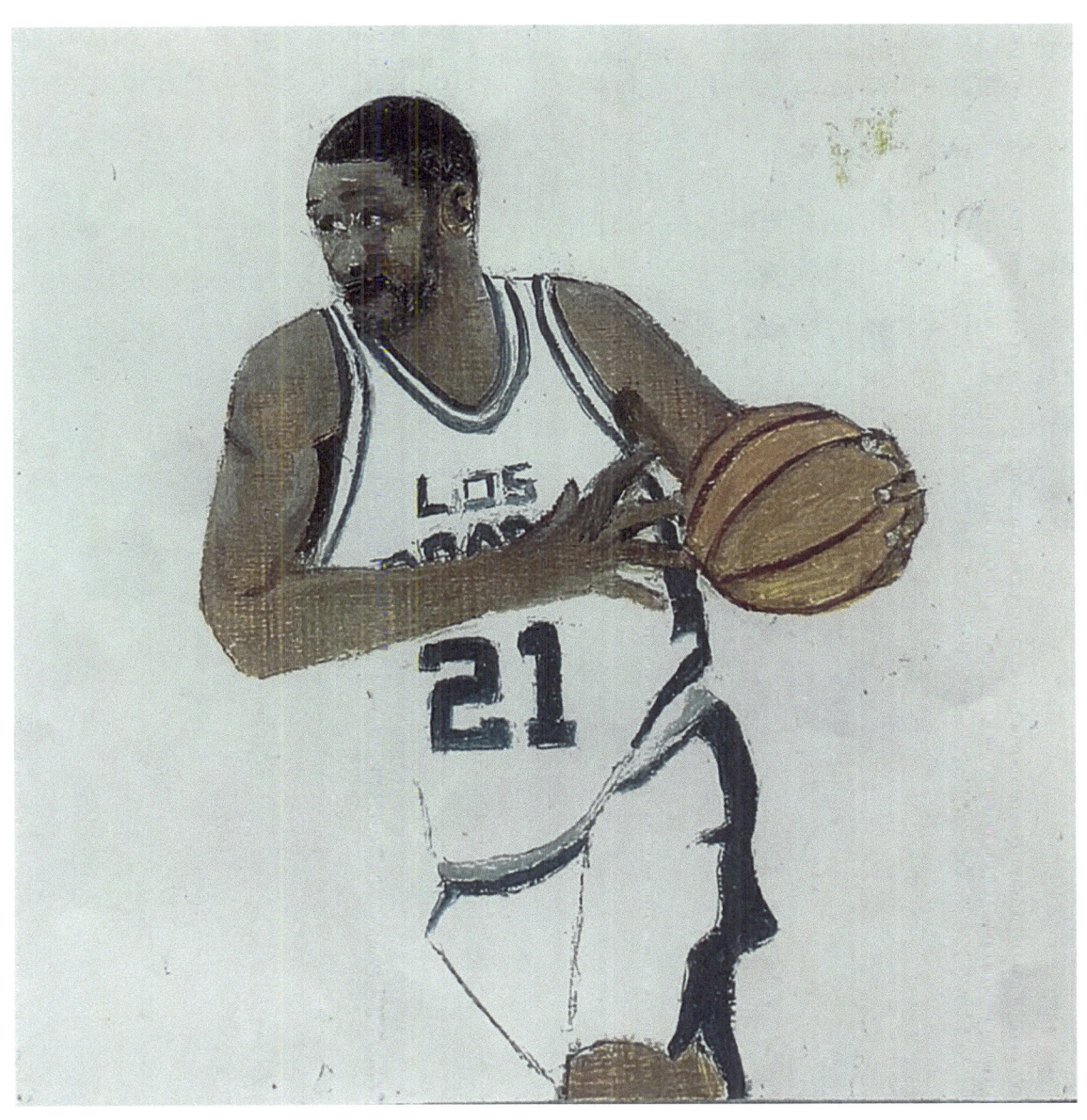

KOBE BRYANT

b. 1978, Philadelphia, PA d. 2020, Calabasas, CA 6ft. 6 in. 212 lbs.

Kobe Bryant succeeded Michael Jordan as the most spectacular and greatest player of his time. He grew up in Philadelphia and Reggio Emilia, Italy, and did not attend college but turned pro in 1996 as the first guard to go directly from high school to the NBA. Bryant played twenty seasons with the Los Angeles Lakers, scoring 33, 643 career points, the fourth highest all time. Among other of his extraordinary skills, he was a "highflyer," winning the slam dunk contest in 1997. In 2006 he scored a career-high 81 points in a game, the second highest behind Wilt Chamberlain's 100 points scored in 1962, Bryant won five NBA championships (2000-2002, 2009, 2010) was eleven times all NBA First Team and nine times NBA All-Defensive Team. He died in a helicopter crash four years after a real ring from the Lakers at age 41.

Kobe Bryant's career stats are:

Points: 33,643 (25.0 ppg) (4th Highest all-time)
Rebounds: 7,047 (5.2 rpg)
Assists: 6, 306 (4.7 apg)

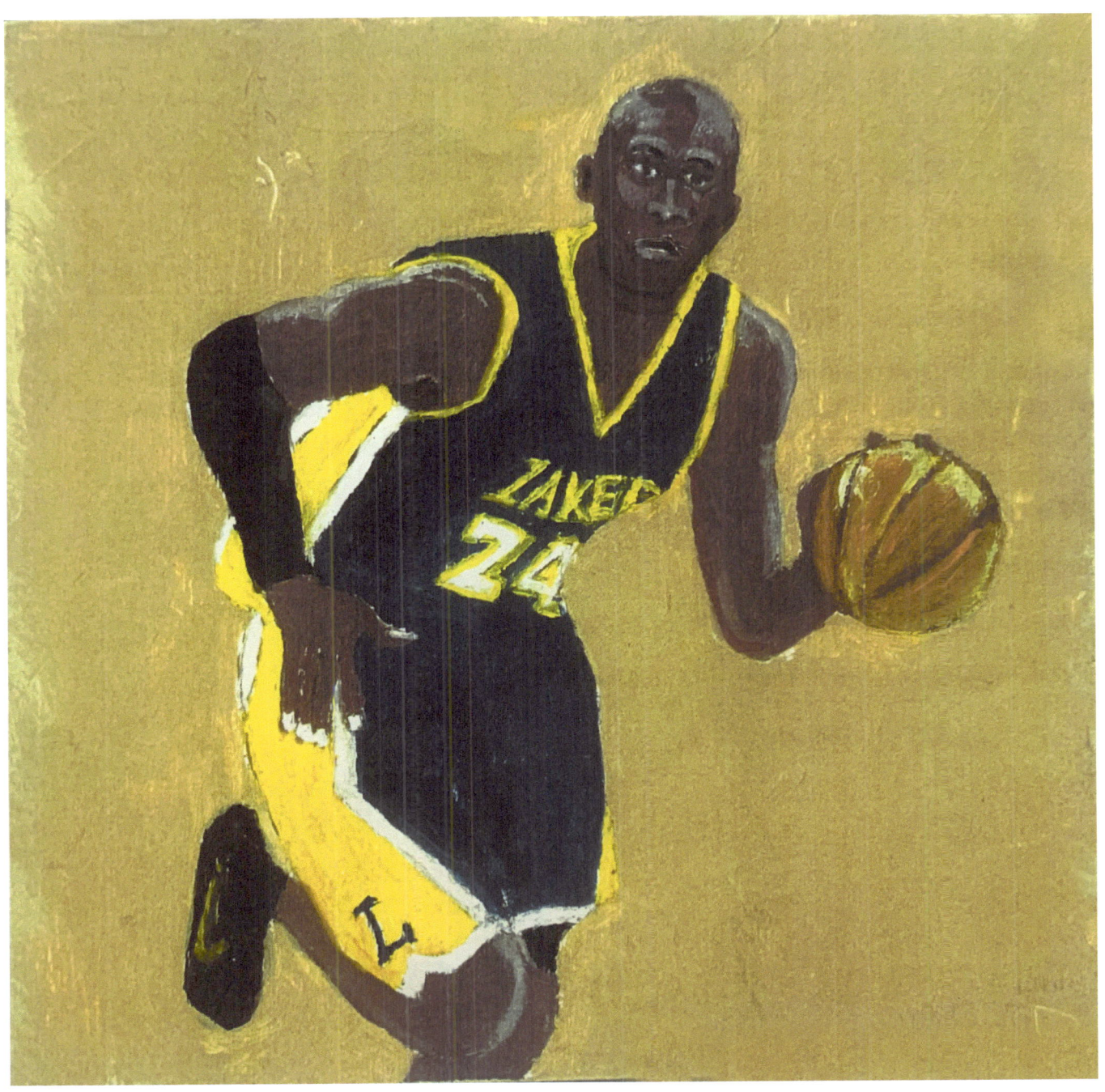

DIRK NOWITZKI

b. 1978, Wurst, Germany 7 ft. 0 in. 245 lbs.

Dirk Nowitzki, widely regarded as the greatest European basketball player, played twenty-one seasons in the NBA with the Dallas Mavericks, leading that team to a championship in 2011. As a power forward or center, he scored effectively both short and long-range. His trademark shot from the field was an unstoppable fade-away jumper. He was accurate from the free throw line 88% of peer attempts and broke the NBA record with a streak of at least 30,000, 10,000 rebounds, 3,000 assists, 1,000 blocked shots, and 1,000 three-point field goals.

His career stats are as follows:

Points: 31, 560 (20.7 ppg)
Rebounds: 11, 489 (7.5 rpg)
Assists: 4, 225 (3.0 apg)

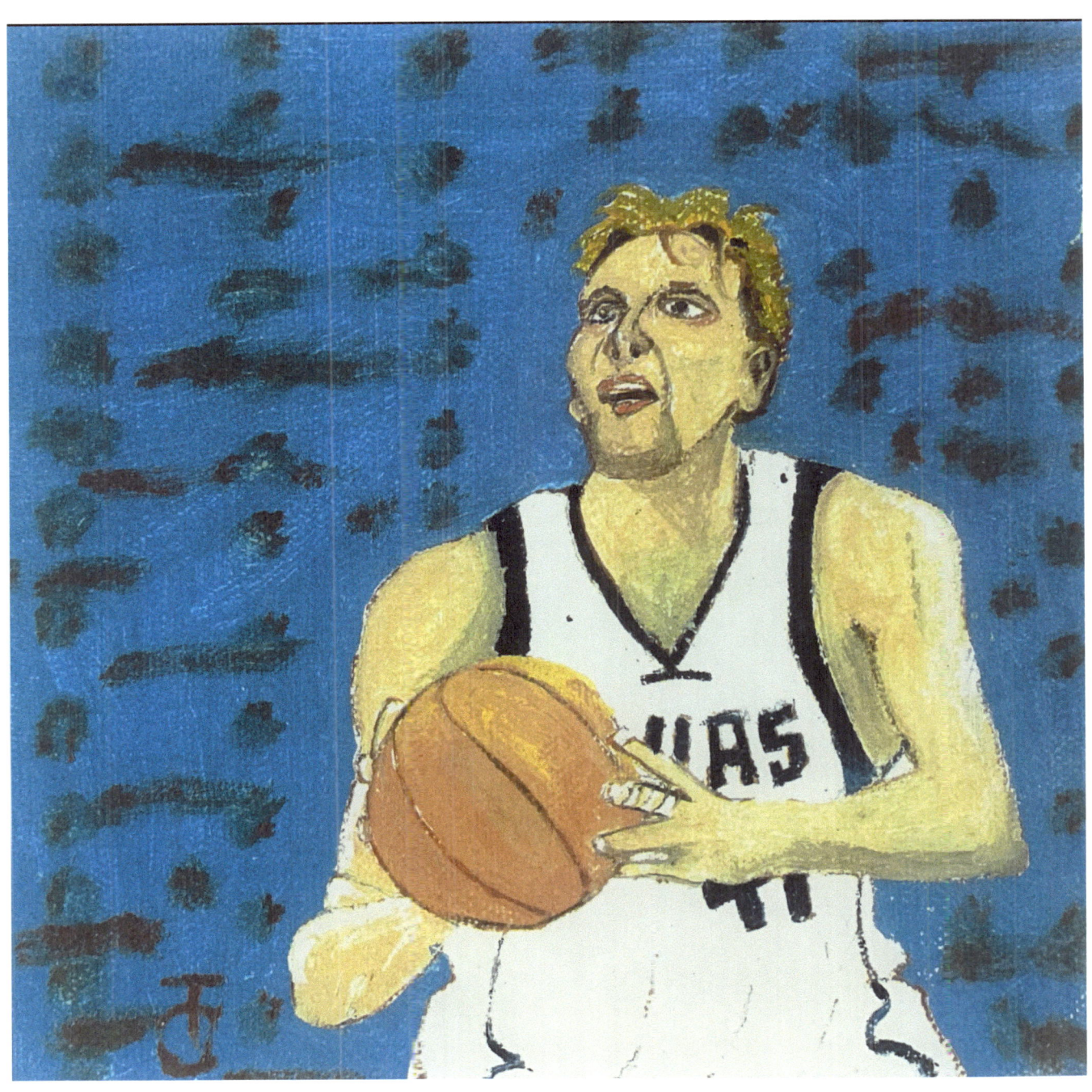

LeBRON JAMES

b. 1984, Akron, OH 6ft 9 in. 250 lbs.

LeBron James followed Kevin Garnet and Kobe Bryant as a prep school-to-pro super star. He signed with the Cleveland Cavaliers in 2003 and played seventeen seasons as either small forward or guard with the Cavaliers, Miami Heat, and Los Angeles Lakers. He won four NBA championships (2022, 2013, 2016, 2020) was thirteen times all NBA First team and five times NBA All Defensive First Team. Hs is the third highest points leader behind Kareem Abdul-Jannar and Karl Malone. Though lacking the grace and overall skill of Jordan and Bryant, some admirers rank James as the dominant player of his modern era.

LeBron James's career stats are:

Points: 35,283 (28.8 ppg)
Rebounds: 9,728 (7.4 rpg)
Assists: (7.2 apg)

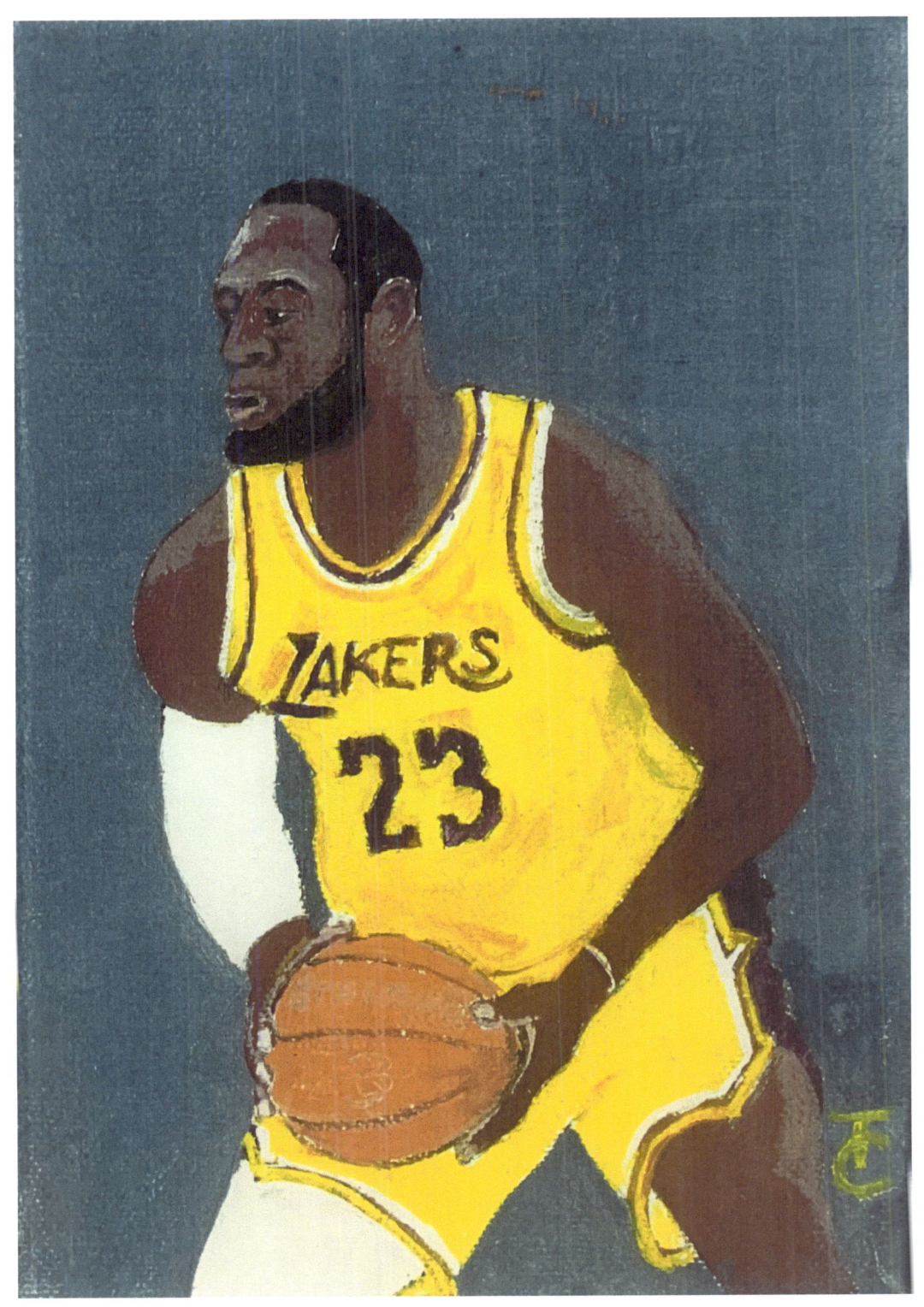

STEPHEN CURRY

b. 1988, Akron, OH 6 ft. 3 in. 185 lbs.

Stephen Curry, the son of former NBA player Dell and younger brother of current NBA player, Seth, had a spectacular career at Davidson College before joining the Golden State Warriors in 2009. Curry is widely acknowledged to be the greatest shooter in NBA history because he has the best career free-throw percentage (more than 91%); he has made the most 3-pointers (more than 350) averaging 44% of his attempts, which is second only to Steve Kerr's 45%; and after thirteen seasons has scored 25, 814 points. He is also one of the top ten-rated dribblers of all time.

Curry has won four NBA championships with the Warriors (2015, 2017, 2018, and 2020), been NBA All-Stars seven times, and the league MVP twice. He and his teammate, Klay Thompson, are the best two-man shooting combo in NBA history.

Stephen Curry's career stats, as of 2023, are:

Points: 25, 814 (26.98 ppg)
Rebounds: (5.5 rpg)
Assists: (5.8 rpg)
Steals: (1.7 spg)

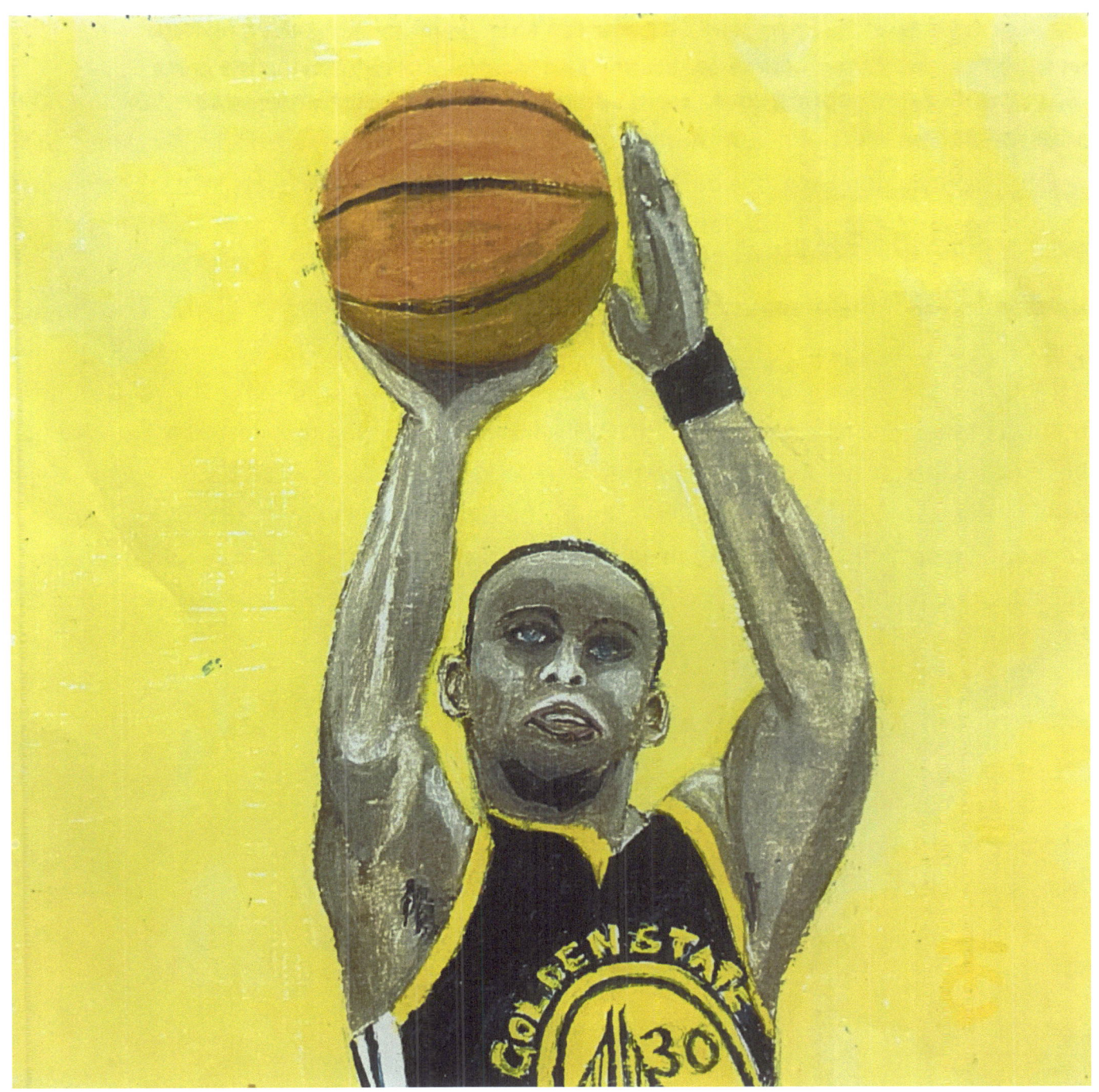

JAMES HARDEN

b.1989, Los Angeles, CA 6ft. 5 in. 220 lbs.

James Harden, a shooting guard from Arizona State University, entered the NBA in 2009 with the Oklahoma Thunder. After three years he was traded to the Houston Rockets, with whom he played nine seasons before being traded to the Brooklyn Nets in 2021. The next year he was traded to Philadelphia.

Harden is one of the greatest scorers in NBA history. By the end of the 2022 season, he had collected 26, 693 career points, twelfth on the all-time list. Playing with Houston, he led the league in scoring three seasons and assists once. He was named to the All-NBA first team six times and league MVP in 2018. His individual scoring feats are remarkable: he became the first N BA player to score thirty-seven or more points and a double-digit assist total in the debut game with his team; in his first two games with Houston, he scored a combined eighty-two points, breaking Wilt Chamberlain's two-game inaugural record of seventy-nine points, made in 1959; with Houston, he had consecutive season-high points total of 45, 43, 50, 45, 53, 51, 60, 61, 59.

James Harden's career stats through 2023 are:

Points: 26, 693 (25 ppg, approximate)
Rebounds: (5.5 rpg)
Assists: (6.5 apg)

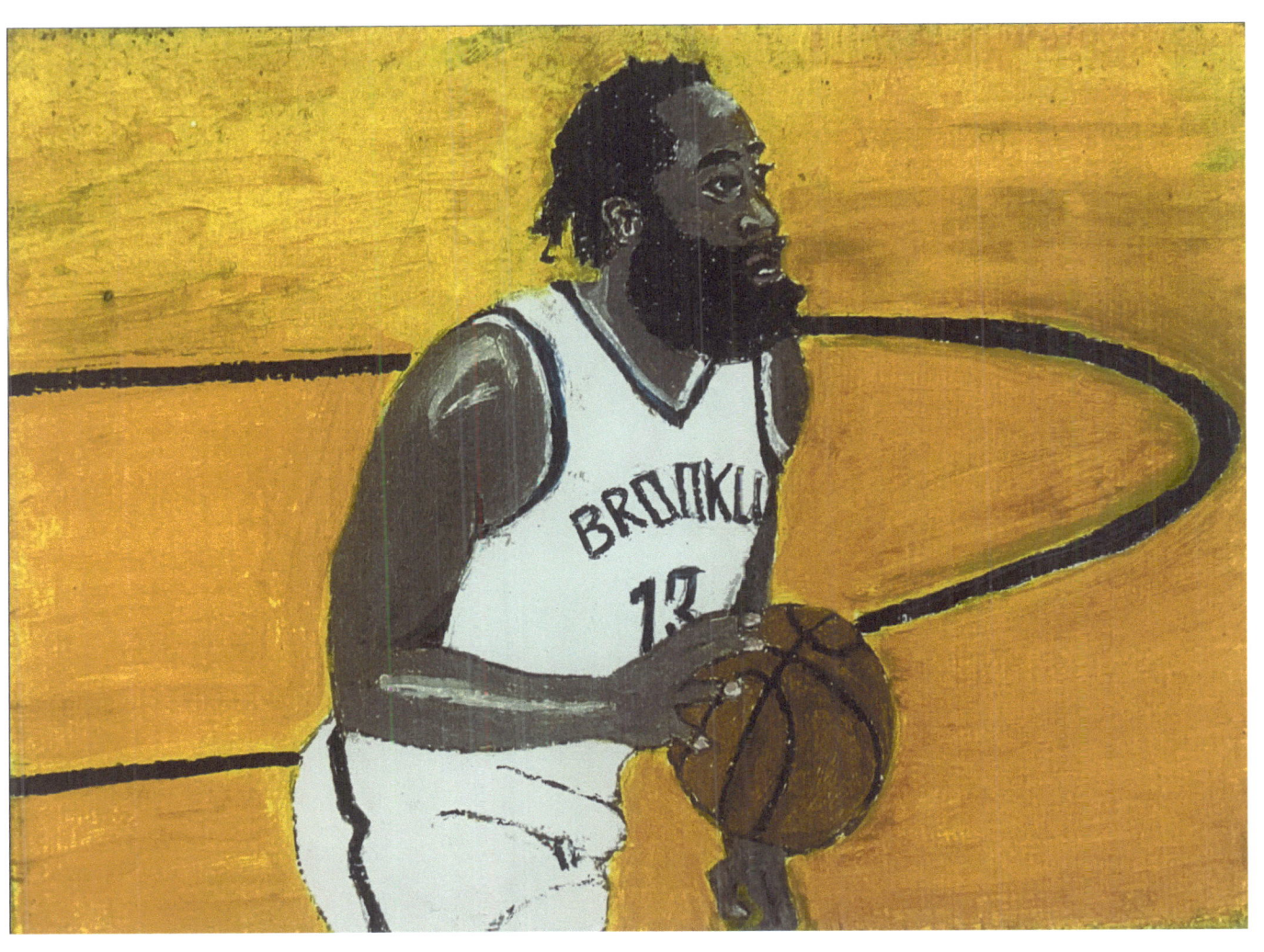

LUKA DONČIĆ

b. 1999, Ljubljana, Slovenia 6ft. 7 in. 230 lbs.

After just five years of playing with the Dallas Mavericks, Luka Dončić firmly established himself as the successor to Magic Johnson and LeBron James as the dominant, big point guard of the NBA. He is a superb passer and 3-point shooter. He scored 60 points in a 2022 game.

His career stats through the 2022-2023 are:

Points: 9,100 Pts. Per game average: 27.6
Rebounds: 2,825
Assists: 2,631

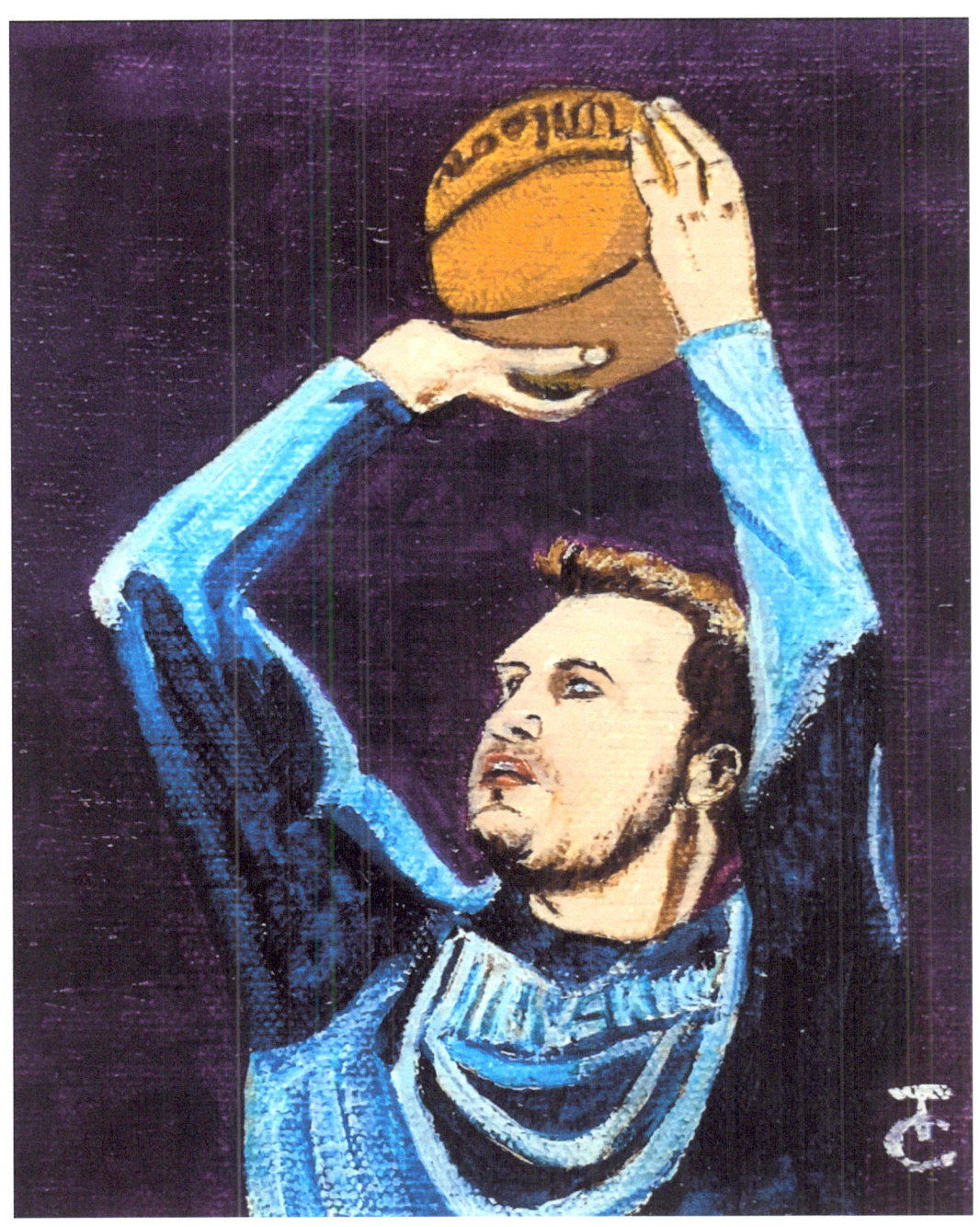